PROHIBITION
— ON THE —
NORTH JERSEY
SHORE
GANGSTERS ON VACATION

MATTHEW R. LINDEROTH

Charleston — London

THE
History
PRESS

Published by The History Press
Charleston, SC 29403
www.historypress.net

Copyright © 2010 by Matthew Linderoth
All rights reserved

Front Cover: courtesy of Dorn's Classic Images.
Back Cover: courtesy of Library of Congress.

First published 2010
Manufactured in the United States
ISBN 978.1.60949.059.1

Library of Congress Cataloging-in-Publication Data
Linderoth, Matthew.
Prohibition on the North Jersey Shore : gangsters on vacation / Matthew Linderoth.
p. cm.
Includes bibliographical references.
ISBN 978-1-60949-059-1
1. Prohibition--New Jersey--Atlantic Coast--History. 2. Prohibition--New Jersey--History. 3.
Organized crime--New Jersey--Atlantic Coast--History--20th century. 4. Gangsters--New
Jersey--Atlantic Coast--History--20th century. 5. Summer resorts--New Jersey--Atlantic
Coast--History--20th century. 6. Atlantic Coast (N.J.)--History, Local. 7. New Jersey--
History, Local. 8. Atlantic Coast (N.J.)--Social conditions--20th century. 9. New Jersey--
Social conditions--20th century. 10. Atlantic Coast (N.J.)--Moral conditions. I. Title.
HV5090.N5L46 2010
364.1'06609749409042--dc22
2010044196

Notice: The information in this book is true and complete to the best of our knowledge. It is
offered without guarantee on the part of the author or The History Press. The author and
The History Press disclaim all liability in connection with the use of this book.
All rights reserved. No part of this book may be reproduced or transmitted in any form
whatsoever without prior written permission from the publisher except in the case of brief
quotations embodied in critical articles and reviews.

CONTENTS

The North Jersey Shore

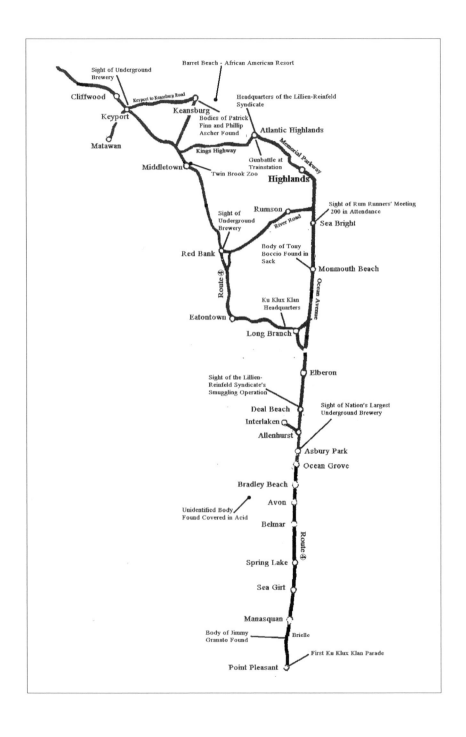

ACKNOWLEDGEMENTS

This book has gone through many versions. Over the course of two years, it has been a short research paper, a master's thesis and finally a book. Over that period of time, I have acquired numerous debts to many people. I would like to thank Dr. Karen Schmelzkopf, Dr. Richard Veit, Dr. Chrisopher Derosa and the entire Monmouth University History Department for their guidance and patience. I need to express gratitude to the librarians at the Asbury Park Library, the Long Branch Library, the Red Bank Library, the Monmouth County Historical Association, the Monmouth University Library and the Rutgers University Library for their patience in answering all of my questions in a professional manner, even though some may have been ridiculous.

A special thank-you is in store for Carolyn Halleran, who patiently read the numerous drafts, proofreading and giving valuable advice on all of them. Again, a special thank-you is in store for Jane Halleran, Lola Adolf, Charlie Halleran and Jules Adolf for providing insight into Atlantic Highlands and Highlands criminal underworld. And thank you to my parents, who listened to me talk about the book, my findings and my complaints, all the while remaining supportive.

Perhaps the person whom I must thank the most is my girlfriend, Sarah Halleran. If it were not for her loving support, this project could never have been completed. And in many ways I would never have known the underside of the North Jersey Shore's history if she had not retold a story her grandmother told her, sparking what would later become the book.

ACKNOWLEDGEMENTS

She has been dragged on more sightseeing trips and research adventures than I can remember. She has listened to me talk for hours about even the most miniscule topics from the book. Moreover, she has put up with me spending thousands of hours in the library (at one point she was sure I was having an affair with the librarian), but through it all she has remained supportive, for which I will always love her.

Chapter 1

CONSTRUCTING A CATASTROPHE

From Ocean Grove to Keansburg, for the tourists and local residents vacationing along the North Jersey Shore, Prohibition, as it did for the rest of the nation, began on January 17, 1920. That date marks the culmination of years of persistent effort by a minority striving to create a "moral" nation, yet their crusade was vested in uncertainty, fear and ignorance. To understand why some on the North Jersey Shore vigorously supported the prohibition of alcohol while others did all in their power to keep the liquor flowing, one must look north to New York City, from where so many of the North Jersey Shore's tourists came. As the twentieth century dawned, a movement spearheaded by a moral minority of white Protestant middle- to upper-class New Yorkers attempted to rid New York City of sin and create a retreat for themselves on the North Jersey Shore where they could design a fantasy world of their making. Very quickly, though, the composure of their vacationland changed, not from the very real threat posed by New York City's vice and crime but from the perceived threat presented by the thousands of southern and eastern European immigrants who similarly wanted to escape New York City's malfeasants.

Before World War I, between 820,000 and 1.2 million immigrants entered New York City yearly. They came mainly from eastern and southern Europe. Jews, Poles, Catholics, Italians and Hungarians crossed the Atlantic Ocean for a chance to earn more money then they ever could in their home countries. Many settled in the area of New York City east of Broadway and south of Fourteenth Street known as the Lower East Side. But, before they even stepped foot in the United States, native residents had already created

a name for newly arrived immigrants. Immigration agents working on Ellis Island watched as immigrants flowed off the ships. "Is there no cessation of this increase?" they asked themselves. London averaged 365 people per acre; in Paris, the number was 434. In some places in New York City, 1,600 people were living on one acre of land. With many arriving without papers, immigration officials took the person's name and then made a notation of "WOP" next to it. Quickly, it became a phrase to describe all immigrants. "Wops. Don't you know what Wops are?" asked Arno Dosch in *Everybody's Magazine.* "Dagos, niggers and Hungarians," they are "a negligible quantity. Unintelligent, sweating creature, who could be killed without counting." Immigration officials may have given newly arrived immigrants a name, but the nation's newspapers provided their readers with numerous reasons to despise them. Jacob Riis in his book, *How the Other Half Lives,* pointed out that only 14 percent of the city's criminals resided alongside the newly arrived immigrants, but many of these criminals were highly organized and ruthless, easily providing newspapers a narrative encapsulating all immigrants.

Just one of many stories that attested to the crimes organized by immigrant gangsters occurred one early April morning. On that day an Irish scrubwoman was walking to work and noticed a coat draped over a barrel. Curious, and perhaps thinking she had just found a free coat, she pulled it away. What she saw inside shocked her. Her screams quickly attracted the attention of a cop walking the beat. He removed the body and found a man—thirty-five years old, husky and with both ears pierced, a common practice among Sicilians—stabbed and slashed so barbarically that the body was almost unrecognizable. Newspapers immediately covered the story. The police believed it was the work of the Italian Mafia. The *New York Times* called it "An Atrocious Murder," claiming the man was a gangster who had snitched because his genitals were cut off and placed in his mouth. The case was never solved. Silence was a prized trait of many Italian immigrants. In southern Italy, where many Italian immigrants came from, people were long taught not to rely on the government. As a saying went, "The law courts are for fools." Instead, a real man secured justice in his own manner or "washed blood with blood," as another saying went. Both sayings were widely reported on by journalists.

For those reading about the story, it seemed like Italians were nothing but outlaws. Many asked themselves, "Who in their right mind would not help the police solve the crime?" after reading about yet another story detailing a crime committed by a recently arrived immigrant. A common feeling developed among native-born Americans: "Let them kill one another." Even for the most ardent immigration advocate, criminal activity among immigrants was hard to

ignore. In reality, gangs that had moved into and developed out of the Lower East Side preyed upon thousands of innocent immigrant victims.

The Lower East Side was broken into two well-organized kingdoms: the Five Pointers and the Eastman Gang. Paul Kelly ruled over the Five Pointers. Kelly (his real name was Paolo Vacarelli), an Italian, was a short, skinny, sensitive man who could call upon an army of over fifteen hundred multiethnic gangsters to control the area between Broadway and the Bowery and Fourteenth Street and City Hall Park. The gang's headquarters was the New Brighton Dance Hall on Great Jones Street. Their rival, the Eastman Gang, controlled by Monk Eastman, held the territory from Monroe Street to Fourteenth Street and from the Bowery to the East River, including the lucrative red-light district. The gang headquartered itself in a saloon on Chrystie Street and had twelve hundred Jewish members. Eastman and Kelly were the primary leaders, but smaller factions allied with either gang operated throughout the Lower East Side. The McCarthys, the Batavia Street Gang, the Marginals, Pearl Buttons and the Squab Wheelman, to name a few, roamed the streets. Worse yet for innocent immigrants, the gangs enjoyed the protection of New York's Tammany Hall, which used them as muscle for hire during election season and let them ply their other violent trades the rest of the year.

The well-organized gangs, small and large, instilled fear in residents. Ignazio Saietta (better known as Lupo the Wolf) controlled the burgeoning Italian Mafia. He was an expert counterfeiter and hired his blackjacking services out to Italian secret orders. Monk Eastman employed blackjackers and guaranteed that extortion money would be paid in a timely manner. Yoski Nigger poisoned horses unless their owners paid him off. Harry Joblisnky and Abe Greenthal operated a ring of pickpockets. Harry "Gyp the Blood" Horowitz, the leader of the Lexington Avenue gang, could break a man's spine over his back in one move, and for a few dollars, onlookers could watch the gory scene. The newspaper accounts helped develop the stereotype that all recent immigrants were criminals. Other newspaper stories would help instill the idea that all recent immigrants were filthy, unsanitary people.

Immigrant children and their parents suffered under the control of the gangs and criminals. Yet making their lives worse were the actual living conditions of the Lower East Side. One Jewish immigrant described the Lower East Side best: "Orchard Street…the crush and stench were enough to suffocate one: dirty children [played] in the street, and perspiring Jews [pushed] carts. Division, Bayard, Canal, Allen, Ludlow, and Essex Streets with their dark tenements, filthy sidewalks, [had] saloons on every corner and sinister red lights in the vestibules of many [of the] small frame houses."

In 1879, the State of New York attempted to ameliorate the housing conditions. Tenements during the period from 1880 to 1900 typically were five- or six-story brick buildings. Since 1867, with the introduction of building codes, conditions in New York City's cheapest housing had improved, but only slightly. The law in 1879 required each livable room in a tenement building to have a window in hopes of bringing light into the typically dark buildings and providing ventilation to remediate the noxious odors emitting the buildings' lack of indoor plumbing or running water. One tenement dweller commented that "many bath[e] no more than six times a year, and often less." Landlords installed forty-six thousand windows in the subsequent years, but many led into airshafts rather than toward the street or back lot. The result was an amplification of sound from crying babies, raucous children and quarrelling couples that echoed from the bottom apartments to the top floor.

Journalists loved to write of the squalor, dirt, overcrowded conditions and odors of the tenement buildings and their dwellers. It fit neatly into the stereotypes held by many of their readers, but the picture presented was not uniform. Some tenements were "clean and picturesque," with potted plants that sat on shelves attached to white plaster walls. Finely stitched bright patchwork quilts were draped over neatly made beds. The apartments may have been small, but some still found a way to make them a home. Yet most accounts depicted the area as America's worst slum. By the close of the first decade in the twentieth century, two stereotypes developed describing recent immigrants: they were criminals and they were dirty. But for New York City's moral minority, immigration was only half the problem.

The Tenderloin (or Satan's Circus, as clergy from the city described the section of New York City from Twenty-third Street to Fifty-seventh, contained between Tenth Avenue in the west and Fifth Avenue in the east) was New York City's most popular red-light district. Macy's department store, Pennsylvania Station (New York's busiest train station), Carnegie Hall and Times Square all resided in the Tenderloin. It was home to an estimated five thousand prostitutes as young as twelve years old who sold their bodies for a dollar a turn. The sex industry was so large that entire streets developed their own specialties as a means to lure in customers. Dance halls on Sixth Avenue showed cancan dancers on stage and, in private booths, explicit sexual dances. On West Thirty-ninth Street, prostitutes performed fellatio on one another, to the disgust of many fellow prostitutes but to the admiration of their clients.

Controlling the district were not criminals in the standard sense but the Democratic Party from Tammany Hall and the city's police officers acting as

New York City's Tenderloin District
1890-1910

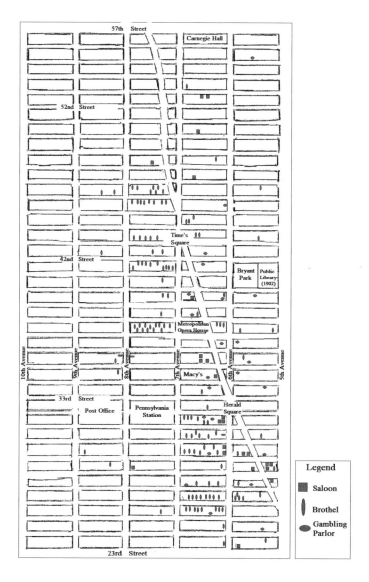

enforcers. Each month, an officer extorted "rent" from brothel owners in exchange for protection. Police commissioner William McAdoo observed, "The manager of a disorderly house, whether man or woman, does not feel any sense of security unless someone representing the police authorities has received money." The alternative was taking place on the Lower East Side,

where ruthless criminals extorted brothel owners and anyone else they felt they could get money from.

To become a police officer in New York City during the late 1800s was simple. All one needed was a $300 bribe to one of the city's four police commissioners. To move up in the ranks, the commissioners required a larger sum of money. To become a sergeant cost $4,000, while the rank of captain cost $12,000. The average yearly officer's salary did not come close to any of the bribes required, thus creating a situation that forced new recruits and veterans alike to maintain Tammany Hall's lucrative scheme. With the taxpaying public well aware of Boss Tweed and Tammany Hall's theft of taxpayer money, for Tammany Hall, using the police force to extort money was the only way for politicians to maintain their lifestyles.

To guarantee no one rocked the boat, hazing rituals developed that rivaled any of those practiced by criminal gangs. In 1900, Cornelius Willemse was a newly minted police recruit working the night shift. He recalled that during his initiation, for a week, to heighten the tension of what every new recruit knew was going to happen, the veterans whispered threats and played practical jokes on him. Then one night, just as the tension had become unbearable, they struck. At midnight as he lay fast asleep in his bed at the station house, he awoke and discovered that veteran officers had tied him to his bed, the room was semidark and a gang of Irish-accented men talked menacingly above him. With raincoats up to their eyes and helmets on, they pulled his bed to the center of the room above the gas heater and, in Willemse's words, "began the evening's entertainment—for everybody but me." The rituals did not stop with one night of torment. Every new recruit was painted green, the Irish veterans' favorite color, and then covered with adhesive tape, plaster tape or sometimes tar and forced to recite the department's oath—never reveal department secrets.

The gangs, politicians and police officers that prospered because of prostitution created the greatest concern for New York City's moral minority. Visiting a prostitute had become an acceptable leisure activity. In an investigation into municipal corruption, committee members discovered that 200 men had complained to the police that they had been robbed while visiting a prostitute. Nearly two-thirds of them lived in the city, and another 28 percent lived in the same ward as the prostitute. Clearly, embarrassment did not outrank their need to recover their lost property. Even more disturbing for New York City's moral minority was the sight of college-aged males from educated and respectable middle- and upper-class families walking in and out of brothels. A study of brothels outside the Metropolitan Opera

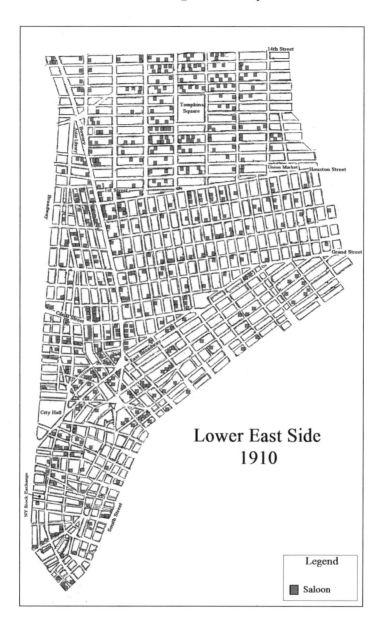

Lower East Side
1910

Legend

Saloon

House found that 550 males visited the block on a single weekend night. Philandering was so commonplace, Officer Cornelius Willemse concluded, that prostitution "was an accepted fact in city life and there seemed little that could be done to check it." Not everyone was as pessimistic as Willemse, but the battle seemed almost insurmountable.

All across the Lower East Side, saloons dotted almost every block. Living in such squalor, few spent their waking moments inside their tenements. Instead, when not working, many spent their time inside saloons. The saloon was the cornerstone of immigrant social life. Clubs held meetings there, organizing everything from card games and bicycle rides to unions and baseball. Politicians came in to shake hands and bought the house a round. In 1899, the Chicago police estimated that half the city visited a saloon at least once a day, and the story was no different for every major and minor city across the country.

The real conditions inside the saloon were terrible. Only a person used to the atrocious conditions that made up most of immigrant housing would find it appealing. Battered furniture filled the room, as did offensive smells that emanated from the rarely cleaned lavatory. Bartenders did not hesitate to serve children and known alcoholics. The saloon was fundamental to prostitution, providing enough liquor to loosen up the customer and supplier and also serving as a locale to do business. The saloonkeeper was "the fixer, the big boss." Of New York City's twenty-four aldermen, eleven were saloonkeepers. Saloons created crime and violence, provided a place for criminals to hang out and provided outsiders with an excuse to abhor every recent immigrant. With New York City's moral minority fed up with the crime, vice and its effect upon their children, many looked south to the North Jersey Shore.

————•◦•————

The North Jersey Shore began as four tourist towns. Long Branch was the first, followed by Ocean Grove, Asbury Park and Atlantic Highlands, the latter three developing in the late 1800s as a direct result of New York City's vice and crime. As one scholar has pointed out, the North Jersey Shore was an attempt by a dissatisfied, upper-middle class to create a stable, homogenous, spiritual environment. This steadily growing moral minority of mainly middle-class, native-born Protestants working in professional fields who believed in puritan values of thrift, hard work and self-denial descended upon the North Jersey Shore. In this vacationland, they held the belief that women were the guardians of their moral customs. Always feminine in their actions and tempted neither by sex nor by drink, women, it was said, were made of finer stuff and held the fabric of society together. Men, too, behaved accordingly. With a moral code based upon chivalry, modesty and reticence, a

system of self-denial and restraint prevailed. Unable to control the conditions in New York City, they escaped to the North Jersey Shore, where, for at least the summer months, they could experience a life of their choosing.

Atlantic Highlands, founded in 1881 as a Methodist resort for those seeking a pious vacation as well as healthful recreations, encompassed four hundred majestic acres. Heading south along the coastline appeared arguably the most famous of the religious-based vacation towns, Asbury Park. Founded in 1871 by James Bradley, a brush factory owner in New York City, the city provided wholesome family-orientated attractions. Bradley installed "queer and extraordinary" sights, caged beasts, fanciful benches, massive marble bathtubs, an old fire truck and a beached whaling vessel all along the beach for the amusement of his visitors. One summer, Bradley even installed a large tank holding two sea lions. The attraction was so popular that he erected grandstands for the many onlookers. All of it was designed to promote "proper" entertainment. Throughout the city, he personally reminded visitors how a good Christian ought to behave and posted signs quoting scripture. Ocean Grove was founded two years prior in 1869, also as a Methodist camp. It had earned the nickname of "tent city" from its wealthy and not-so-wealthy visitors seeking a pious lifestyle. Held within its gates were ornate Victorian-era homes, fretwork villas and neo-Swiss chalets.

Bishop John Wesley, a founding member of American Methodism, had warned against "worldly delights" over a century before, and all three towns strictly abided to his philosophy. The Atlantic Highlands Association required at least one-third of its members to be Methodist Episcopal clergy and held "some type" of religious gathering daily. Asbury Park's churches, as described by the *New York Times*, filled the skies "as thick as the clouds. Puritanism broods over the place," exclaimed the reporter. As early as 1744, Bishop John Wesley forbid Methodists from consuming liquor, and as a result, liquor was never allowed at any Methodist tourist spot.

The Ocean Grove Camp Meeting Association took Wesley's warning against worldliness to the fullest. The town's charter forbid music, dancing, Sunday bathing, tobacco, bicycle riding, peddlers, theater, cursing and "the sexes assuming attitudes on the sand that would be immoral at their homes." Its architecture was appropriately church like, with pointed windows and large spires reaching high into the sky. Homes were constructed on small lots leased, not bought, from the Camp Meeting Association, guaranteeing church control over the character and people of Ocean Grove.

Long Branch's main draw for wealthy capitalists was horse racing at Monmouth Racetrack. The track was so popular that a large iron

grandstand was constructed and claimed national records for attendance. For Bradley, the threat it posed to Asbury Park and the two other Methodist towns seemed very real. During his race for the state senate in 1894, Bradley intended to "clean up the state." He even campaigned by handing out brushes from his New York City brush factory. Bradley was determined to force Protestant morals on the larger population, and gambling had to go. With his election, the State of New Jersey criminalized gambling and forced Monmouth Racetrack to shut its doors, leaving Long Branch without its most alluring attraction. The reaction was almost immediate; wealthy Americans began looking for other places to vacation. With Long Branch declining, the city began to cater to other groups. Riverside amusement park opened in 1898 and attracted a "lower class" of people. Immigrants, the largest among them being Italians, found a welcoming vacation spot in Long Branch. Bradley had set out to prevent outside influences from bringing down the vacationland the Methodist moral minority had created. However, the unintended consequences of his actions fostered a situation where, left with a disappearing clientele, Long Branch became the tourist spot of choice for immigrants. In recognition, the former Iauch Hotel, a grand, three-story hotel and restaurant known for its excellence and attracting distinguished European visitors and affluent New York travelers, changed its name to the Pannaci and began serving day-tripping immigrants.

Just as New York City's moral minority escaped to the North Jersey Shore, so, too, did many recently arrived immigrants, except immigrants sought out the better living conditions and ample employment opportunities offered along the North Jersey Shore. In Asbury Park, they settled in the area behind the train station, which quickly became known as "Little Italy." In Atlantic Highlands, they settled at the bottom of the hill on the outskirts of town. In Long Branch, they settled throughout the city. Italian immigrants established themselves on the west side of Red Bank next to the town's garbage dump. Many immigrants found work within the area's large service industry. The service industry from 1870 to 1910 saw a five-fold increase in jobs, two and a half times greater than industrial employment opportunities. But as more and more immigrants moved to the North Jersey Shore, so, too, did their culture, threatening the moral minority's vacationland.

Hysteria and a new form of crime for the North Jersey Shore appeared as a result. The Black Hand and white slavery drove fear into the residents and tourists of the North Jersey Shore. The Black Hand, while presented as a unified group existing within immigrant communities throughout America's largest cities, was anything but. Instead, what newspapers described as another attack by the Black Hand was in reality an attack by gangsters, immigrant criminals and union organizers. Most attacks were preceded by a letter. Always written in the most respectful manner, the message was always the same: concede to our will or you will die. Italians bore the brunt of the stereotyping. Labeled as "bomb throwers" because of their supposed collusion with Black Handers, those living along the North Jersey Shore looked at the Italian colonies differently as unions attempted to organize and Black Hand letters began appearing throughout the area.

Aside from the tourist industry, Eisner's factory—a garment factory in Red Bank—employed the largest number of immigrants, over seven hundred of them, mainly men from Italy and Poland. Numerous young, native-born women worked in the factory as well. Sigmund Eisner, progressive for his time, was well respected among the business community and was himself a German Jewish immigrant, having come over in the 1870s. When he opened his garment factory, he demanded it be constructed to the highest sanitary standards of the day, providing the greatest amount of light and air possible for each worker. He told the *Red Bank Register* that whenever he placed a bid on a contract and was matched by another factory he always received the contract because of his factory's modern design. Eisner cared so much about the well-being of his workers that he even rented his home on Mechanic Street to his employees at a reasonable rate. As far as Eisner and the rest of the native-born Red Bank residents knew, the immigrant workers were perfectly content. In many ways, they were, but they wanted a union. In March 1912, the employees of the factory decided to walk out, just as garment workers in New York City were doing. It was a show of solidarity and strength. Eisner could not believe it. In an interview with the *Red Bank Register*, he explicitly pointed out, it was not the women who wanted this strike but the Italians and Poles. They had even "molested" the "American girls" when they tried to return to work. Eisner continued in the interview that he had tried everything to settle the strike. He even offered to bring in an arbitrator to settle any disputes after the men returned to work. As far as he knew, the men had no grievances; he said that they had received orders from New York City. Since the union refused to give in, he was forced to hire new employees, but he held no grudges. The striking men were welcome to

return to work, but he was going to begin hiring anyone who came in on a first come first served basis. On the night of March 22, the union responded with a bomb placed beneath the porch of Eisner's Mechanic Street home and set it off, shattering windows and destroying part of the front porch. Everyone knew it was the immigrants and their "foreign ideas," but the police never found who planted the bomb. The town was outraged even worse. It was a clear sign that the Black Hand had infiltrated the immigrant community. It was only a matter of time before it struck again.

They did not have to wait long. In December, the Black Hand kidnapped Mamie Petillo of Leonard Street, Red Bank, daughter of a prosperous junk dealer, and held her for three months in New York City. The *Red Bank Register* wrote, "A son of sunny Italy rarely makes a complaint of a criminal of his own nationality." With few clues, police believed that the girl's abductors returned her after her parents paid a ransom. The people of the North Jersey Shore did not know what to do. Immigrants were destroying the seclusion of the North Jersey Shore. The only one not afraid seemed to be James Bradley.

In 1911, Bradley cracked down on what were referred to as the "beer arks." Many Italians made their living delivering beer from Neptune, a wet town, to homeowners in Asbury Park. Under the Wilson law of 1890, shipments of hard alcohol and beer were permitted into dry areas for personal consumption. Even so, Bradley was outraged. "The beer arks do more harm than an equal amount of thieves," he said in a public address, and he ordered the police to arrest anyone attempting to transport liquor through the city. Facing the loss of their income, owners of the beer arks sent Bradley a secret letter: "If you don't stop your prosecution of merchants of beer, you will know quick the power of the Black Hand." Unfazed by the threat, Bradley responded: "If their threat of death was carried out, I hereby instruct my executors to spend my hard earned money to have you hanged or electrocuted." The beer arks were shut down and Bradley lived, but the Black Hand kept operating.

Eisner's factory was struck again in 1912. This time, the workers were striking for better wages. The union sent a man down from Newark to speak on nonviolent techniques at a meeting held in Columbus Hall. Addressing the crowd, the union leader pleaded with the crowd not to use bombs or any other violent means to get what they wanted. He pointed to what happened after the last strike. Eisner hired a private police force to keep out union men, and later the Red Bank Police Department took over control. The strikers were not impressed; they had a plan worked out already. This time they were going after a larger target—the factory itself—and they had figured out a

way to sneak in the explosives. Andrew Sehkulsky, a twenty-eight-year-old Polish immigrant who was married with three children, walked to the front of the hall dressed in the uniform of the Red Bank Italian Band. He pulled up his sleeves and showed the union men their plan. Attached to both of his arms were two bombs. Shocked, the organizer from Newark immediately ordered Sehkulsky to leave or he was going to call the police. If the next strike were to succeed, workers would need the support of the town council. Sehkulsky reluctantly left and walked the few blocks to the West End Hotel Flats, where he was renting a room. Just as his building came into sight, the bombs still strapped to his arms went off, instantly severing his left arm at the elbow, destroying his left eye and shattering his right arm. The *Red Bank Register* was a small newspaper with perhaps several thousand readers. Printed once a week, rarely did it have large, eye-catching headlines. Both bombings involving the factory workers were reported on with large bold letters and filled the front page. The editors of the paper were remarkably liberal for their time, but many of the readers were not. Dedicating such a large portion of the front page to the story only raised the level of alarm.

Not everyone was as brazen with the Black Hand as Bradley was. When Mrs. Chandler, the wife of Fair Haven's postmaster, received a letter declaring, "Look out for a robbery on April third," and signed "the Black Hand," she was terrified. Her letter, as it turned out, was nothing more than a practical joke played on her and several other residents of Fair Haven by children. With the recent history of bombings and threats of death, in the eyes of the older stock of Americans the immigrants living and vacationing on the North Jersey Shore were something to fear. They were no different from those living in New York City. Bombings were not the only thing those along the North Jersey Shore feared. White slavery became an issue that moral minority vacationers did not take lightly.

According to the fiery literature of the day, Jewish and Catholic immigrants brought with them "foreign ideas" that condoned prostitution. Even though studies had shown that native-born Americans also visited prostitutes, the large number and competitive nature of prostitutes operating on the Lower East Side led many to believe that Jewish and Catholic immigrants did not see trading in girls as wrong. Rather, Clifford Roe, a reformer and prosecutor from Chicago, wrote in his book, *The Great War on White Slavery*, "They are held in high esteem among members of the communities." Other reformers asserted that businessmen or motherly women traveled throughout the countryside to procure girls by promising them marriage, romance, an escape from their dull lives, the exciting night life and the prospect of high-

paying jobs. All of it was a carefully organized system by immigrants to fill the void from a lack of immigrant women.

In Roe's investigations, he learned that women were being shipped across the country at the cost of fifty dollars from New York City to Chicago, New Orleans and Boston. The white slave trade infected almost every major city, and behind it all were the Russian Jews. In 1911, after coming to New York City to investigate the conditions in Lower East Side personally, Roe discovered that the situation was more serious than he had imagined. Italians had moved into the trade.

Congress was appalled over Roe's discoveries and asked the Immigration Commission to investigate the situation. The commission found that the allegations were a sad reality, declaring, "The white slave traffic is the most pitiful and the most revolting phase of the immigration question." They recommended that the federal government forbid the transportation of persons from one state, territory or district to another for the purpose of prostitution. In 1910, transportations of "persons" was switched to "women," and the White Slave Traffic Act (more commonly referred to as the Mann Act) was born. President Taft signed the bill into law and allocated $50,000 to the fledgling Bureau of Investigation, the precursor of today's FBI, to enforce the new law.

With the law on their side, reformers played off people's fears of immigrants and presented the most sensational stories of foreigners destroying white womanhood. One popular book stated, "FOR GOD'S SAKE DO SOMETHING," while another presented a story of girls kidnapped and taken to Roman Catholic convents, where they were barred in rooms and sexually abused by foreigners.

Warnings quickly came to the North Jersey Shore. Being so close to New York City, full of prime, innocent young women, the "threat" was very real. In June 1913, the fear became reality when a twenty-year-old white Protestant woman from Keyport, Lucy Smedes, disappeared after traveling with a man from Asbury Park to visit her family in New York City. Her brother searched tirelessly throughout the summer for her, but his efforts were in vain. Even still, the family did not want to inform the police or newspapers that their daughter had fallen into a life of sex and shame. In September, a female leg was found floating in the Raritan Bay, just off the Keansburg shoreline. Fearing the worst, the Smedes family finally went to the police to identify the body. It was not her. The family was relieved, but she was still missing, and who knew what awful things were happening to her? With the police notified, the Bureau of Investigation quickly tracked her down in New York City where she was visiting with family, not locked away in an immigrant

brothel. The next year, the area would not be so ill prepared. A film and lecture, *Traffic in Souls*, traveled throughout the area. Promoted as an event that "every mother, daughter or sister should see," the film presented the threat to the "innocent girls" living along the North Jersey Shore.

Hysteria took over the North Jersey Shore. An Italian resident of Asbury Park became just one victim of the old stock's xenophobia. On his front lawn, the man erected a flagpole and flew both the American and Italian flags, only with the Italian flag above the American. Returning for the summer, Judge Peter F. Dodd and two friends, Fred Sutton and Isaac Storer, appalled at what they saw, immediately went to the man's home, ladder in hand. They tried to explain to the man that the American flag always flew above all others, but he would not listen. Excited and yelling in Italian, the man motioned for them to leave. The three men ignored his pleas and promptly stood their ladder up and removed his Italian flag.

By the end of the first decade of the twentieth century, the Anti-Saloon League (ASL) and the Woman's Christian Temperance Union (WCTU), two fledgling organizations, found growing support among those fearing the lawlessness that immigrant saloons and culture were bringing to the nation. The Anti-Saloon League (founded in December 1895) and the Woman's Christian Temperance Union (begun in 1873) suddenly found their mission of ridding the country of the saloon and alcohol on the national stage. The ASL was the organization that would ultimately find the greatest support.

The election of 1912 gave the ASL its mission statement. In 1912, Woodrow Wilson's presidential campaign slogan championed his "New Freedom." Vehemently believing in states' rights, Wilson adhered to the Jeffersonian dogma of a weak central government. In Wilson's mind, the federal government's power should only be used to deter any special privileges or artificial barriers that would inhibit personal energies and competition in business, therefore allowing individuals—without hindrance from large corporations with the support from special interest legislation passed by the federal government—to achieve economic success. Decisions made on the local level would serve the people best. Wilson's ideas were in stark contrast to Theodore Roosevelt, who was running under the newly formed Progressive Party. His concept of "New Nationalism" took a paternalistic approach that would bring corporations under complete federal control and protect the laboring man. He proposed social justice objectives, a minimum federal wage for women, a federal child labor law, a federal workingman's compensation and federal intervention in labor disputes. The election of 1912 was a turning point in American history. The incumbent president, Republican Howard Taft, with support from only

the Old Guard Republicans, received just 23 percent of the popular vote. The country overwhelmingly supported progressive initiatives. The election of 1912 decided how they would be achieved, either by the federal government or on the local level through reform organization. The people chose the latter, voting Wilson and his "New Freedom" into office.

The ASL was well in tune with the country's beliefs and immediately went to work. In Congress, the ASL helped push though the Webb-Kenyon Act of 1913, which closed the interstate loophole that had irked Bradley so greatly and prevented any area from truly going dry. The bill passed both houses with such a large majority that it easily overrode President Taft's veto. The ASL could not believe the enormous support the bill received. The following year, it planned to ride its success with a test vote for the Constitutional amendment that would eventually become the Eighteenth Amendment, declaring that the bill would remove the vital question from corrupt politicians by placing it in the hands of voters "demanding their rights." The bill followed the idea of local decision by putting the prohibition question on the ballot and allowing citizens to determine the fate of alcohol in their own states.

Through its numerous monthly publications, the ASL reached a larger audience, pushing the message that the saloon was the root cause of America's problems. The saloon was "The Headquarters of Murders," as the title of one essay proclaimed. Another warned that drink caused children to stay out of school to support the family because the father was a drunk. Other ASL pamphlets insisted that a vote for liquor indirectly nurtured prostitution. "Liquor and lust, the inseparable twins," the essay claimed. As the decade of the 1910s closed and the 1920s drew closer, support for national prohibition was gaining ground just as intolerance reached new levels of acceptance. The Eighteenth Amendment became an attempt to control recently arrived immigrants, but it would also unleash an explosion in criminality.

Chapter 2

THE VOTE FOR
PROHIBITION

"Do Not Count on New Jersey"

Since 1914, the Anti-Saloon League had fought tirelessly for national prohibition. President Wilson's "New Freedom," based upon local decisions, gave the ALS a plan of attack. Immigration and the resulting problems, both real and perceived, provided many with a supposed reason to ban the saloon. By February 1917, the ALS's movement became reality, with the House Judiciary Committee declaring, "In view of the strength shown by the prohibition movement in a large part of the country, we cannot conceive of a good reason to deny the states the opportunity to amend the Constitution." With that blessing, the push to have the necessary thirty-six states ratify the amendment was on. From state capitols to church pulpits, reformers urged state legislators to ratify the amendment.

On January 8, 1918, Mississippi became the first state to put the new amendment up for vote. The state ratified the measure in less than fifteen minutes, followed closely by Virginia on January 10. By the end of the spring, five other states—North Dakota, Maryland, Delaware, South Dakota and Massachusetts—had joined the ever-growing contingent of dry states. By the end of the year, the nation was hurriedly becoming dry. Prohibitionists rejoiced that they only needed one more state to secure a dry America and a return to a moral existence. The honor of being the thirty-sixth state and securing the amendment went to Nebraska on January 17, 1919. By the end of the day, two other states—Missouri and Wyoming—pushed the margin of victory to forty. Mandated by the amendment, Prohibition was to take hold one year after ratification. The

date was set. January 16, 1920, would be the last time any American could manufacture, sell, barter, transport, import, export, deliver or furnish any intoxicating liquor. Through the Volstead Act, enforcement of the new law fell under the auspices of a new federal agency, the Bureau of Prohibition. Even though victory was secured, eight other states still needed to vote, and all but one were expected to pass the measure. As one reformer noted to a *New York Times* reporter, "Do not count on New Jersey." In New Jersey, the question was still very much undecided. In 1919, New Jersey voters had two important decisions to make. First, they were to choose a new governor, and second, they had to choose whether to support the Prohibition amendment. Since the measure was already decided, any vote in favor would be a sign of solidarity with other prohibitionists. However, a vote against the amendment would signal to the federal government that the state of New Jersey did not approve of the measure. On the campaign trail, the governor's race became a forum for the Prohibition amendment, with the Republican Party putting its full weight behind the movement and arguing that it was the only way to combat the problems facing the nation.

No other time than in 1919 were the nation's "problems" more obvious. An estimated one million industrial workers were on strike, including the members of the Boston Police Department. The Bolshevists had just taken

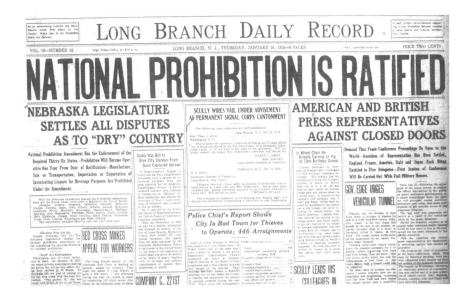

The front page of the *Long Branch Daily Register*, January 16, 1919.

over the Russian government, and industrial workers' insurrections seemed poised to take the country down a similar path. Intolerance quickly became an American virtue. Anti-evolution fundamentalists, prohibitionists, book censors, defenders of the moral order, Jew haters, African American haters and Catholic haters all wrapped themselves in the American flag, claiming they were the protectors of the Founding Fathers. They quickly learned they could defeat whatever they wanted by painting it with a "red brush." World War I had just ended, and propaganda had fostered militant patriotism. One either became a "100 percent American" and believed in the teachings of the Founding Fathers and the Protestant church or else was labeled an "un-American" Red.

In April 1919, thirty-six bombs were uncovered in the New York City Post Office, intended for the nation's leaders and businessmen. It was obvious to many that they had come from the Lower East Side, home to many alien radicals. The immigrants, first and now second generation, vacationing along the North Jersey Shore no longer were simply outsiders. No matter from what land they heralded, they all became un-Americans. The Republican Party took up the initiative and became the "100 percent" Americans' party, appealing to extreme nationalism and always putting America first.

Early on, New Jersey Democrats chose to support the working-class factory workers, immigrants and women, making Prohibition out of the question for the Democratic Party of New Jersey. During the campaign, New Jersey Democrat leader James R. Nugent released a damning report. Having carefully reviewed the correlation of crime and prohibition over forty years in Ocean Grove, Asbury Park and areas within a one-mile radius, Nugent concluded that controlling people's morality through law did not work. Areas under Prohibition accounted for 87 percent of crime committed in all of Monmouth County. Furthermore, seven out of ten murders to occur in Monmouth County had occurred in those areas. In a speech in Long Branch, he continued the Democrats' attack against the Constitutional amendment. "This election will determine if the American people can be choked into a state of submission by private organizations," he warned the packed audience. The hall erupted into echoing cheers as Nugent told the audience that the present spirit of unrest could be traced back to the Anti-Saloon League. "These pseudo reformers have coerced a congress composed of cowards. In New Jersey the law never will be enforceable." The Democrats had tapped into the unrest felt by many working-class New Jerseyans. "No beer, no work" was the slogan of more than 180,000 union workers. Promising large-scale strikes if Prohibition took hold, they found

Governor Edward I. Edwards.

support among New Jersey's 1,000 liquor dealers, brewers and members of the tourist industry. The odd group formed a protective league to fight Prohibition enforcement.

Their candidate was the man who "doffed his hat to no man," Democratic state senator Edward I. Edwards of Jersey City. Just before the election, Edwards appeared before the protective league's convention in Atlantic City. Addressing the crowd, he asserted that, when elected, he would follow the league's plan of fighting the Eighteenth Amendment all the way to the Supreme Court if necessary.

Challenging Edwards was New Jersey state controller Newton A.K. Bugbee, Republican candidate for governor. Bugbee was invited to attend the protective league's convention, but as the reporter covering the scene deduced, "the roast given to him before the convention…may have reached him." On the campaign trail touring Bergen County, he addressed the issue of Prohibition by answering a letter from a body of ministers asking where

he stood on the issue. He stated that the Prohibition issue was over and, as governor and a member of the Republican Party, promised "to uphold the Constitution of the United States and of New Jersey." He went on to explain that if elected, his Democratic opponent, Senator Edward I. Edwards, and the Democratic Party would "nullify" the Eighteenth Amendment. Bugbee made his position known. Betting that he could carry the rural vote, he pushed the rhetoric even further when addressing a crowd in Trenton. "There is urgent need of thorough Americanization in New Jersey…New Jersey has always ranked first among the states on loyalty and devotion to the government." But now, "when a program of organized lawlessness is offered by one of the great political parties, the need is doubly emphasized when it is considered that thousands of persons are being induced to accept this propaganda of disloyalty." The campaign became not an issue over Prohibition but a matter that would determine the future of "American ideals and American institutions."

Edwards, on the other hand, understood his constituents and pledged to keep New Jersey "as wet as the Atlantic Ocean." On the eve of the election, he confidently estimated a winning majority of fifty thousand and, furthermore, the Democrats and their anti-Prohibition stance would sweep all state elections. Edwards did not win by fifty thousand as he predicted; rather, the plurality was only ten thousand and the Democrats did not sweep the state with their anti-Prohibition platform. On November 5, 1919, Bugbee admitted that he had lost, attributing his failure to New Jersey's "wetness." He might as well have said that it was because of "foreigners." One of the counties Bugbee did carry, and where foreigners were despised, was Monmouth County. The county went Republican on every other election held in 1919 as well. From freeholder to state senator, the county voted in an overwhelming majority for the "100 percent" American Republican candidates.

Comparing the situation the nation found itself in to the conditions that existed prior to the Civil War, Edwards announced just three days after his victory that the state of New Jersey, in preserving the sovereignty of the people of the state, "will not lift a finger to aid the Federal government" in enforcing Prohibition. Even Edwards did not realize how divided the people of the state were on the issue of Prohibition. Edwards only won by ten thousand votes in a state with a population of just over three million. The margin between "wets" and "drys" was minimal, considering that women could not vote. Still, Edwards did not back down on his campaign pledge. In the interim between the election and when he took office, Edwards

conferred with the "brightest" legal minds in aiding the state's fight against the new law.

Shaken by their loss at the polls, the members of the Anti-Saloon League had to do something about the threat facing their noble experiment. In December, G. Rowland Munroe, attorney for the ASL, appeared in the office of the attorney general, papers in hand, questioning Edwards's legality to hold office. Munroe and the league claimed to have evidence that Edwards had used $25,000 of his own money to finance his campaign. Furthermore, twelve wet assembly members likewise had broken the Corrupt Practices Act. Unfortunately, the ASL waited too long. According to the act, one must file the proper paperwork within thirty days of the election or the argument becomes moot.

The ASL knew its motion was a lost cause, but it had to do something. Governor-Elect Edwards was being defiant. Continuing his campaign against Prohibition, he ordered the attorney general to file suit with the Supreme Court. The case claimed that the Eighteenth Amendment created a centralization and authority of the federal government without the consent of the New Jersey people and interfered with taxable revenue for the state.

The Anti-Saloon League responded much more quickly this time, calling Edwards a "1 percent American" for not "observing" the law of the United States Constitution in the state of New Jersey and those who supported Edwards as "3½ percent" Americans (referring to the alcohol content in beer). As the battle for Prohibition in the state grew fiercer and every attempt by the ASL seemed to be fruitless, the league announced that it is the "host of America Protestantism" for which it is the "fighting right arm" against the "indignant wets" and "Roman Catholic Church." Edwards assailed the ASL for its populist rhetoric, describing the self-proclaimed "100 percent" Americans as nothing more than "a half of 1 percent American" and "organized fanaticism." The people of the ASL could do nothing. They had been diminished to accosting Edwards and his constituents with bigoted remarks. However, their populism set the tone for the fight over Prohibition in New Jersey in the coming years.

With the summer fast approaching, New Jersey still had not ratified the Eighteenth Amendment. That did not stop the tourist industry along the North Jersey Shore from preparing for the throngs of tourists about

to inundate the area. Prohibitionists planned celebratory parades while criminals thought of ways to use the Prohibition situation in New Jersey to their advantage and business owners struggled with the question of whether to follow the law. The summer of 1920 was like no other summer along the North Jersey Shore. As Fredrick Lewis Allen observed, a revolution in manners and morals was about to take place.

The start of the summer saw parades from the WCTU in Red Bank marching down West Front Street. The parade celebrated those states that had ratified the Eighteenth Amendment. Forty-five women dressed in white carried signs with the names of states that had ratified the amendment. They were followed by women carrying signs for New Jersey and its sister states of Rhode Island and Connecticut, all three dressed in black, as they paraded through the streets. They represented the states that had not ratified the amendment.

Alcohol, the lifeline of many tourist establishments, was gone. The WCTU cared little. Its "noble experiment" had become reality. Comparing the Eighteenth Amendment to the Magna Carta, Declaration of Independence and Emancipation Proclamation, the WCTU rejoiced in the drys' victory. This was going to be the first dry summer along the North Jersey Shore, and there was much revelry in order.

That summer, the WCTU may have been joyous, but its work was far from complete. Secretly, several men no one had ever seen before came to the area. They traveled covertly throughout the area selling liquor from the trunk of their sedan. From Keyport to Asbury Park, business owners purchased cases of liquor at the price of five dollars a quart. Those buying liquor were breaking the law; however, the men selling it were not. Under Governor Edwards's program to keep New Jersey wet, the men applied for and got one of the four thousand permits doled out by the state government to sell liquor. It did not take long for the county detectives to catch on to what was happening. Through sting operations, they caught the numerous restaurant and hotel owners. They even caught a few Long Branch police officers purchasing liquor. When questioned by Judge Lawrence, George Tindall, a man arrested for selling liquor, stated that yes they had sold liquor to the cops, but "cops aint [*sic*] much on the buy." Instead, it was tourists.

Peter Dibb, proprietor of the Sheridan Hotel in Red Bank, was arrested for selling liquor and told the judge that he had originally obeyed the Prohibition law. For the first three months, he held out against selling liquor, he pleaded with Judge Lawrence. "Then the shoe shop, all of the stores" began selling liquor and did big business of it, while he was losing out. Not

swayed by his excuse, Judge Lawrence asked, "If all the others were doing something, which would lead to their being hung, you were willing to do the same and be hung along with the rest." "Yes sir, every time," Dibb replied indignantly and was fined $500. Yet some were fined even higher amounts, the largest being $1,000. In total, the county took in $18,250 in fines, all from hotel owners. Interestingly, even though evidence clearly pointed to several women illegally selling liquor, none was found guilty. A loophole that few seemed to understand, except for career criminals, got them off the hook. Under state law, women, for all intents and purposes, were agents acting on their husbands' behalf. In the case of Mrs. Siciliano, "it was said she actually sold liquor," but the three sales she is known to have made were done with the "consent" and "knowledge" of her husband, thus making her husband, Paul Siciliano, guilty for her acts. The loophole worked so well because the husband was not indicted. The prosecutor would now have to convene a grand jury, have Paul Siciliano indicted and find evidence to counter the almost certain argument that Paul Siciliano was not aware of his wife's actions. It would be a strategy used repeatedly by Prohibition violators.

Those arrested over the summer did not appear before the court until December. The same week the *Red Bank Register* covered the hotelmen's cases, the paper revealed that liquor was still in the area, and now local residents were getting in on the act. An Italian man driving a truck through Middletown crashed head on with a sedan. The subsequent investigation turned up eighteen bottles of whiskey in the vehicle. When asked where he had purchased the booze, the man stated in broken English that it was from "a man in Long Branch."

Paul Siciliano was the man. Living in Long Branch, before Prohibition he operated several gambling halls in the city. When Prohibition took hold, he and many other gangsters were provided with a new lucrative market they could not pass up. Siciliano, a low-level member of New York City's Italian Mafia, had enough connections that allowed him to become the first local resident to start selling liquor. Yet he did not have enough power to prevent arrests.

In July 1921, again one of Siciliano's men, George Arbuckle, a twenty-three-year-old man from Jersey City, found himself on the wrong side of the law after falling asleep in Long Branch while waiting to meet his contact. He was driving a truck with forty-nine cases and eleven bottles of El Bart Gin that was distilled in Baltimore before Prohibition and disguised as ketchup bottles. He told police he was to meet with "another party" on "a bridge in Asbury Park," where they planned to distribute the liquor to hotels throughout the city.

The Vote for Prohibition

In the first year of Prohibition on the North Jersey Shore, liquor remained readily available. Even in places where it had always been forbidden, one could easily find hard alcohol. At the time, most would have agreed that immigrants were behind the illicit liquor trade, and they were correct. However, as every business owner knows, one cannot survive without customers. Supplying the bootleggers' customer base were the youth, including those of the moral minority.

A sort of honor system took the place with the supervision of the youth. Previously, strict parental control and stern chaperones prevented any youthful indiscretions. The times changed, however, and now the consensus on youth controls lay with their family background. It was thought that if a child was brought up in a respectable family, the system would inherently work. Unfortunately, laziness is never rewarded. What resulted shocked the older generation. "Nice" girls openly drank, smoked and retired "where the sharpest eyed chaperon could not follow." In darkened rooms or parked cars, they engaged in the "unspeakable" acts of necking and petting. The flapper was born, and as Francis Scott Fitzgerald wrote in *The Great Gatsby*, she was lovely, expensive and nineteen. Families were torn on how to handle the smoking, gin, all-night automobile rides and rising hemlines of their daughters. In 1919, the average length of the hem from the ground was 10 percent of a woman's height. In 1920, it doubled to 20 percent—to put it another way, from an average of seven conservative inches to a scandalous fourteen. Young men and women shunned questions, lied and spoke back. "At least we are not dirty minded hypocrites," was the overwhelming consensus of the youth of the day. Speaking of World War I and the resulting feelings among the youth in 1920, John F. Carter wrote in the *Atlantic Monthly*, "The older generation had certainly pretty well ruined this world before passing it along to us."

Because of Governor Edwards's program, liquor was inundating the North Jersey Shore. To the delight of tourists, the rum flowed freely from Asbury Park to Atlantic Highlands, promising 1922 to be a lucrative year for tourism. The *Long Branch Daily Record* noted that at some points "the string of machines [reached] almost unbroken from Red Bank to the seashore." Greeting them was an unusual sight. A twenty-year-old New York woman named Charlotte Randall worked to pay for her vacation as a sign painter dressed in men's khaki overalls. That year's annual polo matches at the Rumson County Club promised to be as crowded as the beaches were. With President Harding and a number of other government officials invited to attend, special measures were taken to ensure that traffic flowed smoothly. A

special arrangement was made with the Aeromarine Company of Keyport to fly planes from New York City directly to the country club, and extra ferries and buses were scheduled to handle the thousands of expected visitors. Bootleggers made provisions for the big match as well, landing two hundred cases of liquor near Wagner Creek in Atlantic Highlands. With another six to twelve ships laden with liquor loitering off the Asbury Park shoreline, the polo matches promised to be as festive as they ever had been.

Under the Volstead Act, liquor was not allowed within three miles of the United States coastline. Lawmakers thought the boundary was far enough, but daring fishermen, who routinely headed out to sea, found the distance less burdensome than hoped. The polo games marked the first time rumrunners landed illegal liquor on the North Jersey Shore. Even with the Coast Guard under orders to report any attempt of smuggling immediately, Prohibition agents decided not to wait. With no proof, just a feeling that Italians had something to do with it, seventeen Prohibition agents stormed Asbury Park's Little Italy. Raiding fourteen different restaurants and confectionery and grocery stores, agents turned up bottles of whiskey in each location. One week later, agents visited six more places, finding even more liquor. So much liquor was found in Asbury Park that Prohibition agents believed the city was the hub of the bootleg business for the entire North Jersey Shore. Andrew Bowne, the lead agent on the case, claimed "automobile parties" from resorts ten to fifteen miles away "frequently visited" those areas. However, farther north in Keansburg similar raids took place. Prohibition agents, assisted by county detectives, succeeded in finding 229 cases of liquor. So much liquor was uncovered that they needed a large truck to transport it to the county courthouse in Freehold. It should have been a clear sign that liquor could be found throughout the North Jersey Shore. The raids during the last week in August and first week in September were the first of many planned to break up the liquor traffic, but without a clear understanding of the situation, they would not succeed. Prohibition agents had no idea how so much liquor was making it into the area. Nor did they understand where it was coming from and by whom it was controlled.

Perhaps the efforts of law enforcement agents could have prevented bootlegging from becoming such big business, but forces were well out of their hands and, in many ways, forced residents to cross the line to the criminal underworld. Secretly, an organization of Jews and Italians was moving into Atlantic Highlands, planning to use the town as their base of operations for rumrunning. Government agents failed to realize that the small Methodist retreat of Atlantic Highlands had shunned the ways of its

past and now took full advantage of the Prohibition situation. They received an inkling of an idea of what was happening after the murder of a former Prohibition agent in Red Bank.

Charles Scandalis was a prominent Prohibition agent working cases in New York and New Jersey under the supervision of Chief John D. Appleby. A large, husky man, he made the perfect undercover agent. He was known as "Mysterious Charles" to the news-reading public for his ability to crack cases no one else could. There was a suspicious ease with which he was able to do his work. Rumors abound over how Scandalis could afford a room in the Peninsula Hotel in Seabright for the summer. With no solid evidence against him, he kept his job for the summer of 1922, but as the weather grew colder, Appleby could not look past the home on Lockwood Avenue in Fair Haven he was renting or the $2,000 automobile he drove and dismissed him from the service. Appleby's assumptions proved correct. Scandalis was running liquor throughout the area. Buying liquor from wherever he could, he would bring it to John Calandriello's bottling plant on Pearl Street in Red Bank, where they cut it with other chemicals to increase the quantity. From there, because he was a Prohibition agent and he had little cause to fear arrest, he delivered the cut liquor to hotels and restaurants throughout the North Jersey Shore. The two men made so much money that Scandalis decided it was fashionable to hire a driver and hired his downtrodden cousin, Charles Papas, to chauffeur him as he made his deliveries. Before Prohibition, Papas worked as a waiter at the Metropolitan in Red Bank and then as a shoeshine. His fortunes turned around when his cousin took him into the business, but it was not enough. On Monday, September 11, 1922, at about eleven o'clock, the three men were at Calandriello's plant discussing money. For weeks, Papas had claimed the two were shorting him pay. So when he failed to receive his $3 salary for driving Scandalis around all day, it sent him into a fury. A heated argument ensued. Scandalis grabbed for an iron bar and struck Papas on the head. Dazed, he fell back but quickly recovered. From his coat pocket, Papas pulled a revolver and fired, striking his cousin in the forehead, causing the back of his head to explode. His lifeless body fell to the floor. Calandriello held his "close friend" as he lay dying on the ground. Papas escaped to Asbury. Mysterious Charlie died the next day, and Papas turned himself in, where he told his entire story.

The police never followed up with the story. Had they, perhaps they could have uncovered the organized system of bootlegging developing in the area. Calandriello and Scandalis were close friends. Unable to hide his emotions, Calandriello openly wept as his friend was taken away to the hospital. Clearly

there was a close connection between the two, yet Calandriello's connection went even further to a group of up-and-coming youthful criminals being groomed to conquer the bootlegging business. But for many within the new Bureau of Prohibition, corruption was not a problem, and the agents were fully capable of stopping liquor trafficking. It was a naïve assumption that even the superintendent of the New Jersey Anti-Saloon League believed, stating, "I don't know of anyone who can make a dollar go further than policemen and dry agents."

Chapter 3

AS WET AS THE
ATLANTIC OCEAN

Prohibition did not create criminals. It produced the opportunity of a lifetime. For younger criminals trying to make it in a world where jail time was easy to come by and death even easier, huge profits were up for the taking. With the blessing of Edwards, 1920, 1921 and 1922 were years of opportunity. However, three years into Prohibition, stockpiles ran low. In stepped Arnold Rothstein, the man who allegedly fixed the 1919 Cincinnati Reds–Chicago White Sox World Series.

Known as "The Brain," he was a genius at dealing with underworld enterprises. The son of Russian Jews who escaped the pogroms, he grew up in a wealthy household in an Orthodox Jewish community on Manhattan's Upper West Side, far removed from the vice-ridden, gang-controlled Lower East Side. As stockpiles ran low, he came up with an idea to import liquor. Like so many of those who grew wealthy selling bootlegged liquor, Rothstein longed for the American dream and was willing to do anything for it. Rothstein loved the other nickname given to him, "The Big Bankroll." With large sums of money always on hand, he was the man to turn to when untraceable cash was needed. In 1920, when the Communist Party planned strikes in the Garment District, they turned to the only man they could. He provided a loan of $1,775,000 at an interest rate of 25 percent to the party. As an act of goodwill, he provided protection from the police when "the rough stuff started happening." That was his style: pleasing his customers while taking large sums of money from them. He ran his gambling operation in the same manner, and when Prohibition became law, he commanded

those whom he financed to do the same. Rothstein, the ever-thoughtful gangster, could not trust the older criminal leaders. The "Moustache Petes," Joe Masseria and Salvatore Maranzano, controlled the growing Italian Mafia, running all types of rackets out of the Lower East Side. Even if Rothstein had approached them, they would not listen out of fear of losing control of the Mafia—never mind that Rothstein was a Jew. What he needed was his own group of young and eager criminals.

The first group he established consisted of Irving Weschler, also known as Waxey Gordon, a Polish Jew who before Prohibition worked as a pickpocket and opium peddler on the Lower East Side, along with Max "Big Maxey" Greenberg of St. Louis and Max Hassel from the industrial town of Reading, Pennsylvania. Like so many in the underworld in need of cash, Waxey arranged a meeting with Rothstein to borrow $175,000 and discuss the gang's plan in detail. Before Rothstein agreed, he mulled over the plan. The gang wanted to establish a rumrunning ring out of Detroit using Canadian intermediaries acting as purchasing agents. To Gordon and his associates, the plan seemed perfectly feasible, but Rothstein knew better. Flush with cash from fixing the 1919 World Series, the money was not the issue—the distance was. Detroit, as far as Rothstein was concerned, was a world away. Controlled by an unfamiliar underworld, the threat to his investment was too great. Instead, he proposed a different plan to Gordon.

Their nondescript meeting on a random park bench in Central Park would have a lasting impact on the North Jersey Shore. Rothstein proposed an idea that would make everyone very wealthy. Rothstein would provide Gordon, Greenberg and Hassel with the $175,000 they wanted, but they would buy liquor from a Rothstein associate hiding out in Great Britain instead of going through Canada. Gordon agreed with Rothstein's plan. Harry Mather, a native of the Lower East Side, took the money, bought twenty thousand cases of whiskey and shipped it to the States. The plan worked just as Rothstein thought it would. The freighter landed its cargo somewhere off the Long Island coast, marking the beginning of rumrunning.

Rothstein did not stop with just Gordon and his gang. An up-and-coming group of young criminals also caught his eye. In June 1916, Salvatore Lucania, better known as Charles Luciano, was released from jail after serving time for selling opium, and he joined forces with Meyer Lansky, Vito Genovese and Ben Siegel. All young and impressionable, the gang, led by Luciano, was exactly the type of gang Rothstein was looking for.

The attention from Rothstein was a blessing for all of them. Luciano, just sixteen, was an uneducated, unmannered youth destined for a life of

institutionalization. Genovese, in his early twenties, was faring slightly better. Having left the Lower East Side for Long Branch, he found himself providing protection and driving trucks for Paul Siciliano. His ability to drive was not remarkable, but his ability to kill and "rough up" had no equal. Meyer Lansky, born Meyer Suchowljansky, was an avid reader and only nineteen. Benjamin "Bugs" Siegel—who was even younger, only twelve—earned the nickname of "Bugs" because it was said he was crazy.

The origin of the gang is an odd story worth retelling. On the night of October 24, 1918, Meyer Lansky was walking home from his job at a tool and die shop on the Lower East Side. Hearing screams from a woman coming from an abandoned tenement house, he quickly grabbed a metal pipe lying on the ground and charged into the building. Inside, he found one man beating another and a woman pleading to Lansky to stop them. Just as he brought the bar down on the young man's head, the police rushed in and arrested all three of them. Down at the Fifth Street station house, police figured out that Luciano had caught his girlfriend in bed in the abandoned house with Ben Siegel, and Lansky had come to save the woman. Since no one seemed too upset over the matter, the police let them go. Luciano let his girlfriend go as well, in favor of his new friends. From that point on, the three men were inseparable. No matter what happened, they could always count on each other, and later in their careers, that friendship would prove invaluable. In 1921, Siegel and Lansky broke away from Luciano's gang and joined forces, forming the Bugs-Meyer gang. Lansky provided the brains and Siegel provided the "muscle" of the gang. Their specialty was providing protection, gunmen, drivers and stolen cars to bootleggers. Their closest ally would always remain Luciano and his gang.

How Genovese joined the gang was never recorded, but his feelings toward Luciano's Jewish friends were, saying to Luciano, "What the hell is this? What are you trying to do, load us up with a bunch of hebes?" His complaints were ignored. Luciano's relationship with Genovese was very similar to the Lansky-Siegel relationship. Genovese was ruthless and never backed down, no matter what the odds were. As he was short tempered and quick to fight, his wife faced his wrath on many occasions. All four owed Rothstein everything. He was the man who gave them the opportunity to become wealthy and powerful.

Across the Hudson River in Newark, New Jersey, several young criminals were following the business plan invented by Rothstein. Joseph Reinfeld, a tall, brown-haired, Polish Jew, immigrated with his family to the Italian section of Newark's First Ward in 1910. Looking more like a Sicilian than

a Jew, before Prohibition, he owned a saloon with his brother, serving beer to his working-class Italian clientele while settling problems and handling the police. He quickly grew to be a man of prominence in the community. When Prohibition went into effect, he kept on selling liquor as if nothing had changed. He had nothing to fear. The police were in his pocket, but the agents of the new Bureau of Prohibition, as he soon learned, were not, and they fined him for selling liquor. Annoyed at the agents and disgruntled over the poor quality of liquor available, Reinfeld began searching for a better way of doing business.

At the same time, Alexander Lillien Jr., a young, like-minded, second-generation Hungarian Jew from Elizabeth, New Jersey, was attempting to break into the Prohibition business. A "poor little immigrant boy," he came to America at the age of eleven. Ambitious, smart and determined to achieve the American dream, he worked as a delivery driver for his father's produce store. Through dating Beatrice Cohen, the woman he eventually married, he met her brother Samuel Cohen, a friend of Reinfeld and con man turned racketeer who introduced Lillien to Reinfeld, marking the beginning of his life of crime.

Reinfeld, through his bar, already had close contacts with the underworld. Lillien, on the other hand, was a simple delivery driver. Before he befriended Reinfeld, his attempt at breaking into the criminal underworld was a much more determined effort. In 1921, with $10,000, Lillien and his three associates—Morris Uram, Samuel Kandel and Nelson Levy—planned to purchase bonded whiskey certificates from two New Yorkers, Katz and Kaplan. Uram met Katz in a backroom of a Newark saloon. Not much was said between the two men. Katz wanted to see the money and count it before handing over the certificates. Uram agreed. Reaching into his pocket, he pulled out the money, took it from its envelope and handed it to Katz. After counting it, satisfied it was all there, Katz said, "Let's put the cash in two envelopes, so they can be sealed and put in the safe. Tomorrow we will meet again and I will have the certificates for you." Uram agreed and took the two envelopes and placed them in the safe, and the two men planned to meet the next day at Sixth Avenue and Twenty-Eighth Street in New York City. Lillien and Kandel went at this time. Standing on the street corner, the two men waited from eleven o'clock in the morning to half past two. With no word from either Katz or Kaplan, the two men returned to Newark and to the safe in the back of the saloon. Upon opening it, they found that inside the two envelopes was nothing but thousands of strips of paper. They had been robbed and, like any victim, immediately called the police. After telling

their tale, the police simply pulled out the New York City directory, showing them page after page of Katzes and Kaplans. In total 1,355 Katzes and 1,090 Kaplans lived in the city.

Whose money they lost is unknown. Most likely it was their own, since all of them lived through the incident. Nevertheless, it was a learning experience. To be successful in bootlegging, they were going to have to think bigger, go beyond the usual underworld suppliers and seek out liquor from countries where liquor was still legal. Lillien, determined not to make the same mistake again, joined forces with Reinfeld with a new idea. Instead of buying liquor from Great Britain, as Rothstein was doing, the two men looked north to Montreal, to a friend of Reinfeld's whose family owned a distillery. The Bronfmans were Russian Jews who, like Rothstein's family, had escaped the pogroms. They settled in Saskatchewan and Manitoba, where they operated several hotels. Partly to supply their hotels, the Bronfmans became distillers of alcohol. When the States went dry, they saw opportunity.

They sold liquor to Reinfeld, who, instead of selling directly to customers, sold receipts that his customer brought out to waiting ships along Rum Row to collect their liquor. The system worked perfectly: Reinfeld shared in none of the risk and all of the profits. Aiding him was Lillien. Working out of Oscar Hammerstein's former summer home on the hill in Atlantic Highlands, he became a facilitator, guaranteeing that shipments would make it to shore. Lillien's secret weapon was a high-powered radio in Highlands at 33 Shrewsbury Avenue. It was operated by Canadian Malcolm MacMasters, who guided the syndicate's freighters from St. Pierre Island, a small island in the mouth of the St. Lawrence River, past the government patrols, straight to the North Jersey Shore. There, Lillien had already bribed government officials, from the local police to the commander of the Sandy Hook Coast Guard station, guaranteeing that orders placed with Reinfeld made it to their final destinations. The commander of the Coast Guard received a special bribe. In exchange for doing nothing, Lillien sent him a quarter case of liquor to pass the time. For his efforts, Lillien asked for two dollars per case, a price that quickly made him very wealthy. Ships routinely arrived with thousands of cases. At the height of Prohibition, the syndicate claimed 8,700 customers and paid out thousands each week in bribes. Gordon, too, continued importing liquor, now using Lillien's expertise. With his profits, he began reinvesting in breweries. From New York State to New Jersey and eastern Pennsylvania, Gordon, Hassel and Greenberg established underground breweries, providing the North Jersey Shore with as much beer as they could drink.

Another man soon joined Lillien and Reinfeld. Abner "Longy" Zwillman—about the same age as Lillien, just nineteen—began his bootlegging career as a truck driver selling liquor he purchased at Port Newark but soon developed a reputation as someone who could deliver his cargo no matter who tried to stop him. Hijackers tried to take Zwillman's truck only once. He put up such a fierce fight that he not only saved his cargo but also caught Reinfeld's attention. Well dressed, smart, level headed and very willing to kill, he was, as Reinfeld put it, "a killer that doesn't look the part." He was originally offered the position of chief of transportation, overseeing all of the syndicate's land distribution and providing protection from hijackers. But Zwillman would not settle for anything less than a fifty-fifty partnership in the syndicate. It was a tough decision for Reinfeld. In 1923, Zwillman pulled off the largest liquor hijacking in Prohibition's short history by ripping off a shipment of Joseph Kennedy's scotch whiskey. After that, Reinfeld had two options: bring Zwillman into his operation or risk having a competitor just as smart and much more violent. The decision was made, and Zwillman joined the syndicate.

<center>———•◦•———</center>

Few could know what was facing them in 1923 as they packed up the car, headed down to the train station or boarded a ferry en route to the North Jersey Shore. The automobile was creating many problems for locals and tourists alike. To think the towns of Highlands and Atlantic Highlands would descend into a world of lawlessness was the last thing on people's minds, when all summer long they had to listen to impatient motorists blasting their horns. The editor of the *Red Bank Register* noted that from Keyport to Red Bank residents complained, "Horns are tooted for an hour or more at intervals of a half minute or so."

The automobile was not only a nuisance but also brought with it a new danger to the people of the North Jersey Shore. Being so new, 1920s drivers demonstrated little skill in handling their automobiles. Deaths became commonplace as the streets crowded with tourists. While riding his bicycle along Hartshorne Road in Rumson, fourteen-year-old Joseph Porter, the son of a former Rumson police officer, became one more victim. He was struck by F.L. Connable's auto, fracturing his skull and killing him. His story was

An editorial cartoon from the *Asbury Park Evening Press*, July 10, 1926.

not unusual. Local citizens began demanding, "The fool killer should be added to the [police] force." The police acted quickly and with vigor.

Keyport established a law against the "lurid wail" of motorists' horns. Over one weekend, the Keyport Police Department issued fifty tickets for various violations. As the area fell deeper and deeper into rumrunning, the

police spent most of their time cracking down on motor vehicle violations. Senora V. Folcombe of New York was particularly agitated over the fine she received for speeding recklessly through Keyport, asking the judge, "What's the use of having a fast car if one could not use it?" She received a fine of ten dollars nonetheless. In Red Bank, an off-duty officer, aided by enthusiastic neighbors, volunteered his time to catch speeders. Through their efforts, he was able to arrest eighty-four drivers.

In 1915, 2.5 million people were on the road; by 1919, the number jumped to 6.7 million. By the end of the decade, the number more than tripled to 23,121,000. The car meant freedom for many, and for no one more than the youth of the nation. Cars became highly stylized. Expert designers created fashionable body designs that were available in myriad colors, from Florentine cream to Versailles violet. The new closed-top designs provided more privacy. The youth thought nothing of jumping into a car and driving off at a moment's notice to another town twenty miles away. Fredrick Lewis Allen quipped, "The automobile destroyed the corner stone of American morality, the difficulty of finding a suitable locale for misconduct."

The behavior of the youth was shocking. They personalized their cars with small metal plates placed beneath the license plate that contained "expressions that in many cases [were] most indecent." The most popular sign, a "nude bathing girl," only reflected what was taking place inside while parked late in the evening. The City of Long Branch, liberal in comparison to other tourist towns on the North Jersey Shore, was so taken back by this new behavior that it created a new law to stop such lurid public behavior. Many motorists found themselves standing before a judge on the charge of "driving with an arm around girl." Driving with two hands on the wheel, given the complete ineptitude of many drivers in the 1920s, was a great idea, but the attention paid to driving laws blinded the police from events taking place that would have greater consequences for the North Jersey Shore.

———•◦•———

Over the winter of 1923, Rothstein, Reinfeld, Lillien and their bands of underlings had successfully turned rumrunning into an organized system, with ships arriving off the coast of Long Island and New Jersey. The system required a vast network of bribes and transportation both from the ships to land and from the "ports" to the liquor's final destination. They would soon

find a welcoming home and willing labor force in the town of Highlands, a fishing port just at the base of the hill that Atlantic Highlands was built on some forty years earlier.

The town was situated on a small, flat plane reaching out into the Raritan Bay in an otherwise hilly area. Tourists did come to the town, but by far the largest industry was clamming. Some five hundred fishermen and related businesses relied on selling clams to New York City for their existence. The prosperity that afforded many the ability to go on vacation to the North Jersey Shore never made it to Highlands, and now a decision by the New York City Health Department crippled the town's economy.

In 1923, claiming health concerns, the New York City Health Department forbid the importation of clams gathered from Hilton Park to Spermaceti Cove, an area covering all of Highlands. The people of Highlands protested the decision, but the board was correct. All of the waterways along the North Jersey Shore contained more oil, garbage or raw sewage than they did water. A study conducted by the New York City Health Department found that the two major rivers that New York City dumped its waste into, the Hudson and East, had an inadequate amount of water flow for proper disposal of the city's sewage. Both rivers have a cumulative water flow of 10,790,205,000 gallons. Each day, New Yorkers created 1,084,000,000 gallons of sewage, all of which eventually flowed into the Raritan Bay. Even though the bay's waters contained 9.95 percent raw sewage, the commission was most worried over the fact that 1,087,180,000 gallons of water did not make it to the ocean. Rather, it stayed in the Raritan Bay, and the sediments in the water sank to the bottom, where clams ingested the material. In almost every town with a sewage system, the discharge pipe dumped its contents either into the Atlantic Ocean or into the Raritan Bay. Asbury Park actually solved two problems in dealing with its sewage. No one wanted to swim where the sewage pipe exhausted its contents, nor did they want to swim with African Americans. Therefore, the city council turned the section of beach known as the "mud-hole" into the city's black beach. That was not the only problem facing the waters of the North Jersey Shore.

Washed ashore garbage piled up a foot thick in some places. It was not uncommon to bump into the remains of chickens, cats, dogs and putrefying vegetables. Oil slicks covered huge swaths of the bay, killing fish and birds by the thousands. When their oil-soaked carcasses eventually washed up on shore, "the stench, especially on hot days [was] sickening," a reporter noted. Oil was the most pressing problem for the area. Because of the huge slicks, several varieties of fish completely disappeared from the coastline. The

private estates lining the waterfront from Seabright to Asbury Park suffered considerable damage from oil-laden water lapping against their properties, but most distressing was the effects oil had on swimmers. The sticky and gummy oil clung to all parts of the bather. Beach clubs provided tubs of soapy water for bathers, but fewer and fewer people were venturing into the water. Even with the extreme pollution, for the people of Highlands the news that their clams were no longer safe was a shock. The decision by the New York City Health Department put 28.8 percent of the population out of work. When an enterprising gangster came looking for someone to bring an illegal cargo to shore, he found many eager volunteers.

In January 1923, a reporter for the *New York Times* working on a tip went to Highlands. What the reporter found was shocking. The paper ran a lengthy article describing just one night's activities in the "Bootleggers Haven." Talking with one of the rumrunners, the reporter learned that "well known" runners predicted thirty-five thousand cases of high-quality liquor were going to come ashore in "hundreds of different places" just that night. Throughout the town, fleets of trucks sat idling as they were loaded, bound for Manhattan, Newark, Jersey City, Philadelphia, Baltimore and Washington. As the reporter strolled through the town, he observed more and more smuggling activity happening in the open. Walking along the waterfront, the reporter discovered a group of African American men passing around a bottle, joyfully loading a truck and singing:

> *De dry navy gone done to glory*
> *De agents dey seem daid*
> *Lawdy sabe dis whisky*
> *Please, please, please*

The situation was shocking, but rumrunning brought money into the town—a lot of money. A person with a boat could make five dollars for each trip made to and from Rum Row. On shore, each person waiting to unload the boat made one dollar and again another dollar to load the truck. From the restaurants to the boatyards and garages, Prohibition was a boon for Highlands. In an interview with John A. Bahrs, he recalled, "The bootleggers and the people here associated with them made plenty of money. The girls for example had fur coats and wore diamond rings on hands that looked like clubs from opening clams."

With their new night job, many within the Prohibition industry had little to do other than wait around for word of when the next shipment was to

come in. The favorite spot to spend the day became affectionately known as "rowboat row." Located on First Avenue in Atlantic Highlands, it was just blocks from where many of those controlling rumrunning in the area lived. Except for Lillien, those employing the rumrunners were Italians. They found a welcoming neighborhood in the area around St. Agnes Church. The corner of Avenue D and West Highland Avenue became the epicenter of the town's bootleggers. Andrew "Andy" Richards lived next door to the church and, after his death, donated his home to the church to serve as a thrift store. His sister went to work as a teacher at the church's school. Louis "The Wop" Caruso lived down the block. After Prohibition, he would stay in the business, opening a liquor store in town. Vito Genovese moved into a home on Avenue C and West Highlands Avenue. He donated forty-eight dollars each month to the church and invited neighbors from the community to his home for a drink. When the church needed new steps, he happily paid for them. Aside from their illegal enterprises, those in the community remember the rumrunners warmly for their acts of kindness. Working with Lillien and the Calandriello brothers from Red Bank, and with neighbors looking the other way, the rumrunning syndicate became wildly successful. Outside of their communities, however, they were not thought of so highly.

The introduction of rumrunning did not go unnoticed. Sitting just three miles offshore, rum-laden ships were clearly visible to anyone standing on the beach. In Washington, D.C., Deets Pickett, the secretary of the Board of Temperance, Prohibition and Morals of the Methodist Episcopal Church South, declared that the rum fleet must be seized. "The only thing to do," Pickett asserted, "is to detail United States destroyers to round up these ships." The Coast Guard was fighting a losing battle. With powerful engines and highly maneuverable boats that could travel through shallow waters, the rum fleet could easily outpace any pursuing Coast Guard cutter. Worse yet, getting too close to shore usually guaranteed that those waiting to unload the rum ship would open fire on the pursuing Coast Guard vessel. The thick foliage and elevated sniping perch of the hill that Atlantic Highlands is located on created a situation where the men aboard the Coast Guard vessel were at great risk.

Contrary to Pickett's advice, the federal government did not order the navy to apprehend international ships. That most likely would have caused an international issue. Instead, the Internal Revenue Bureau received a fleet of twelve newly constructed ships geared specifically to dissuade the "prosperous smugglers from Atlantic Highlands." With a speed of thirty knots and maneuverable enough to follow small rumrunning vessels into

the shallow tidal waters, each vessel carried two four-inch guns and a six-pounder with orders to fire solid shot. This was more than enough firepower to deter any would be sniper.

The Coast Guard received its new ships just in time. With summer coming and the worst of the winter storms ending, ships departed St. Pierre Island daily heading for the coast of New Jersey. A war was about to begin between rival gangsters vying for control of the area that would cause the people of the North Jersey Shore to fear for their lives.

On the evening of March 23, 1923, a series of three different gun battles took place between rumrunners and hijackers. Aware of the developments surrounding Highlands, the *New York Times* covered the deadliest story of the night in detail. About eleven o'clock, a large rumrunning vessel, carrying several hundred cases of Scotch concealed in burlap sacks below deck, slowly approached the mouth of the Shrewsbury River. In the distance on the moonless night, the captain saw a suspicious vessel lingering in the middle of the river just off the Highlands shoreline. As the captain drew closer, he could make out the outlines of several armed men standing on the deck. From the darkness, a voice called out, "Halt! Turn off your engine." The rum captain turned to his men. "Open fire," he yelled as he pushed the throttle forward, taking his vessel through a volley of return fire. Firing volley after volley, several bullets found their mark as the river lit up with the flashes of muzzle fire as the skiff and three other vessels pursued the rum vessel. Slowed by the cases of liquor, the four vessels quickly caught up with the rumrunning vessel. As they crossed beneath the Highlands Bridge, the largest of the hijacker's boats, with all aboard carrying automatic weapons, pulled alongside. The captain and the crew had no other option but to abandon their cargo and swim for it. Looking back on their vessel, they watched as the hijackers dumped the bodies of their associates into the river.

Those running rum always knew they needed protection. The events that played out on March 23 only reinforced that need. Four men in a trailing sedan always guarded the trucks leaving Highlands. With gangsters moving into the area around St. Agnes and ruthless criminals descending upon the area raiding their ships, the decision was made to bring the local law enforcement into their illegal enterprise. Atlantic Highlands police chief John R. Snedeker was not your friendly local constable. In 1920, he was arrested for beating and choking a railroad investigator while investigating a robbery at the Leonardo train station. He definitely was a person you did not want to cross. For Andy Richards and other rumrunners, he was the perfect man to provide protection. Richards and his men were landing

Atlantic Highlands mayor John R. Snedeker, *Long Branch Daily Record*, August 17, 1933.

liquor using the Mandalay Pier, the ferry terminal where thousands of tourists passed through daily, located within several yards of the large and widely popular Atlantic Amusement Park. The wide-open location may seem foolish, but it provided the greatest protection from hijackers. However, even the thousands of tourists did not seem to be enough to stop the new type of hijacker. Chief Snedeker became a crucial ally in rumrunning. On nights when the syndicate brought liquor in, usually between ten o'clock and midnight, Snedeker and another officer drove to the town's power station and turned the power off to the waterfront. This allowed the syndicate's rumrunners to unload their cargo free from the prying eyes of tourists who might report them or potential hijackers waiting to pounce. After unloading the boats, Snedeker drove the trucks to

the town limits, ensuring that Richards's trucks were not robbed along the way. Snedeker, an enthusiastic participant, spent his bribe money quickly, buying his son a $2,000 seaplane and building two one-story buildings for storefronts on First Avenue.

Gangsters may have gotten their start from Rothstein. His idea of selling respectable people a respectable product, unfortunately, did not trickle down to those on the importing side. As Darwin discovered, only the strongest would survive. Quickly, the North Jersey Shore transformed from a world of pleasure to a world of violence.

Vito Genovese, sitting in front of the Abott Hotel on Shrewsbury Avenue in the Italian section of Red Bank, narrowly dodged shots fired by New Yorkers Guerino Napolitano and Samuel Queen. Earlier in the year, Salvatore Santaniello of New York City was not so lucky. Passing motorists found his body on Seven Bridges Road in Little Silver with four bullet holes in his chest and arms. In his pocket was a memorandum book showing sales of over $2,000 of whiskey. The rum war had begun.

Hijackers were not only roaming the waters. Anyone driving the highways of the North Jersey Shore became a target. Frank Le Conti and his gang from Newark were by far the most dangerous and hated. Le Conti was in the habit of hijacking not only the liquor but also the trucks themselves and severely beating their occupants. Le Conti made a nice business out of selling stolen liquor to hotels and restaurants. For the customers, it did not matter where the liquor came from, especially since Le Conti sold his liquor at a lower price than other suppliers. After selling the liquor, he simply dumped the trucks. Walter Keener, the "Bootleg King" of 45 Bayview Avenue, Highlands, operated his smuggling operation out of his home and used his garage as a liquor warehouse. In 1924, he would be caught with $54,000 worth of liquor in his garage. In 1923, though, his biggest problem was Le Conti, and on the night of October 23, 1923, he got vengeance. One of his men, George Schneider, saw Le Conti and his gang driving in a Cadillac along Memorial Highway on their way to Highlands. Quickly, Schneider gathered some of his closest associates—Ralph Bitters, John Butterfield, Walter Keener, Henry Netiger and his brother George—and jumped into Bitters's Nash car. They caught up with Le Conti and his men at the Atlantic Highlands train station, in the heart of the business section of town. The gateman had closed the road for a passing train. With nowhere to go, both cars immediately emptied. Taking cover behind telephone poles and opened car doors, they began shooting. An Atlantic Highlands police officer watched the entire scene unfold. They fired dozens of rounds that

sent unsuspecting townspeople and tourists "scurrying for shelter." Ralph Bitters was the first to fall, quickly followed by Le Conti. A .38-caliber bullet pierced Le Conti's belt buckle and lodged deep in his abdomen. Mortally wounded, Le Conti's men grabbed him and took off. Keener's men did the same. With Bitters wounded in the shoulder, they headed straight for the hospital in Long Branch. Le Conti's men, thinking he was dead, dumped his body on First Avenue. The whole event lasted only a few minutes. When it was over, the officer who had witnessed everything found a phone and called Snedeker. When the officer returned to the scene, people had converged on the train station to investigate. Chief Snedeker never made it. On his way to the train station driving along First Avenue, he found Le Conti crawling along the road. Rushed to the hospital, Le Conti died the next day.

Hijackings and gun battles continued for the next three Sunday nights, these times just west of Atlantic Highlands in the town of Belford. Tourists and local residents were terrified. Cars began appearing all along the North Jersey Shore displaying signs stating that they carried no liquor. The terrified residents of Belford at least had the safety of their homes to hide in. The people spending a lazy Sunday afternoon in the late summer on the Keansburg beach wished they had. The people wading in the water and sitting on the beach had no idea the beach was the rendezvous point for the rumrunners being chased by the Coast Guard off in the distance. With the chase nearing the shore, a truck loaded with several men pulled onto the beach. They saw the chase and jumped out with pistols in hand. For those caught in the middle, the scene did not feel right. Some tried to escape, but it was too late. The men on shore opened fire when the cutter came within range. Expecting the Coast Guard men to flee, the rumrunners beached their boat and began wading past the bathers to their waiting truck. Suddenly, the crack of automatic fire was heard. Bullets began cutting up the waters around the bathers, sending "scores of women and little children screaming in fright." The rumrunners beat a hasty retreat, leaving their cargo to be confiscated. By 1923, rumrunning and bootlegging along the North Jersey Shore was in full operation. Violence overwhelmed the area. Every day, citizens were now very much in the middle of the vicious rumrunning war.

Methodists were losing one of their favorite vacation spots. Atlantic Highlands was supposed to be a place to escape the perils of modern life, except now the perils were transpiring from the town. According to the man who presumably knew everything about the matter, Roy Haynes, the federal Prohibition director, four times as many foreigners as citizens violated the Prohibition laws. The figure seemed right on the mark for those observing

what was happening all along the North Jersey Shore. Local newspapers all carried stories of Italians breaking the law. In Asbury Park, raids took place in the Italian section of the city. In Long Branch, the police rounded up scores of Italians in possession of liquor. Worst of all, the prolific smuggling of liquor through Highlands and Atlantic Highlands was controlled by Italians living around the Catholic church. Haynes's figures, as it turns out, were incorrect. Haynes based his numbers from New York City court records. However, New York City had not collected any type of data as to a defendant's citizenship since 1919. It did not matter; everyone knew who was causing America's problems.

Most people find comfort in believing what they see with their own eyes on a daily basis, especially when newspapers and authority figures reinforce those ideas. Crusaders and reformers had been saving the United States for almost two decades now. Prohibition was a hard fight but offered the best solution to the problems facing the country. If another fight was needed to ensure foreigners understood the benefits, those living along the North Jersey Shore were going to give it to them through a redesigned and fanatically patriotic organization, the Ku Klux Klan.

Chapter 4

THE BEACH, THE BOARDWALK
AND A BED SHEET

O n the evening of August 31, 1923, the Ku Klux Klan came to Perth Amboy looking for new recruits. Oscar Haywood, pastor of the Baptist Church of the Covenant of New York City and lecturer for the Ku Klux Klan, was the much-anticipated speaker. He came to Odd Fellows Hall, where 250 personally invited men anxiously waited to hear him speak. Haywood carefully prepared his notes. Standing in the foyer of the side entrance just to the left of the stage, he shuffled through them, making sure they were in the right order. Haywood took the podium at about 8:00 p.m., just as an ominous crowd four times the size as those inside formed around the hall. It was no surprise that the Klan was coming to Perth Amboy that evening. Even though the invitations were secret, word quickly spread. The mob that formed that night was unanimous: the Klan was not welcome in Perth Amboy. By 8:30 p.m., the mob had surpassed 1,000. The police, sensing something was about to happen, called for backup, but it was too late.

Someone from the crowd called out, "This is an American meeting, they can't keep us out." With that, five hundred people rushed the doors, pouring into the hall just as Haywood was discussing the "deceitful" Jews. Haywood called out, "Jews are not permitted. They are not Christians." Isaac Alpern, president of the Perth Amboy Trust Company, standing in the doorway, yelled back, "Then why do you exclude the Catholics?" "I am coming to that," Haywood brazenly shouted back. The crowd was incensed. Sitting in the audience, a furious potential Klansman yelled out, "I came to hear a talk on Americanism." Loud cries and applause came from the future Klansmen.

Rage turned to violence. The riot had begun. Their target was Haywood. Alpern disliked Haywood and his message but did not want to see harm done to him. Running to the front of the hall, he fought his way through the rushing mob and Klansmen to save him. With several police officers, they forced Haywood into the alcove to the left of the stage. Haywood had no idea what hatred the people had for the Klan. Defiant the whole time, police had to pick him up and carry him outside as rocks and anything the mob could find came shattering through the windows. "They seemed possessed with the idea that they must beat Haywood," one reporter noted. Klansmen tried to escape, but the mob blocked the doors. Reinforcements finally arrived. But by now there was no stopping the madness; the mob had control. "My God! Don't do that. That's murder!" an officer screamed as the mob attempted to drop a Klansman's severely beaten, unconscious body down a sewer. Helmeted police beat their way to the fire hydrants for the firefighters to connect their hoses, but the mob re-formed, broke through the police line and cut the hoses. The police could do nothing other than look on as Klansmen's cars became the next target. The mob was pushing two of them into the Raritan Bay just as two carloads of Klansmen drove past. The timing could not have been worse. The first car gunned the engine and made it, but the following sedan did not. The mob forced the doors open and ripped those inside out, threw them to the ground and beat them as others overturned the car.

Police fired tear gas into the crowd, allowing some to escape from the hall into the woods behind it. Some tried to run across the roof into another building to a waiting police van, but the crowd caught on and overturned the van, pulling those inside out, punching and mauling them until they, too, managed to escape into the woods. At 5:30 a.m., with twenty-five Klansmen still trapped, the police finally called in a bus large enough that it could not be overturned and, under heavy guard, escorted the remaining Klansmen to Asbury Park, where locals and tourists awaited their arrival.

Real Americans, 100 percent America, true Americans—whatever one wanted to call them, in reality they were middle-class men and women of the Protestant faith in fear of the America that was being constructed in the 1920s. The Klan had come to the North Jersey Shore earlier that summer, where they received a warm welcome. The Klan announced itself on the North Jersey Shore in 1923 through a quarter-page advertisement in the *Asbury Park Evening Press*, declaring: "Give Heed to this Fiery Summons—A Special Konklave Will Be Held—On the Deadly Day of the Woeful Week, of the Gloomy Month, of the Year of the Klan LVII."

The Beach, the Boardwalk and a Bed Sheet

The event was to take place on June 2, 1923, and the Konklave was held in Point Pleasant at the Central Methodist Church, where Reverend Dr. L.C. Muller wholeheartedly embraced Klan ideology and invited them to his church because, as Muller put it, "any real American should." The Klan invited the press from Philadelphia, Newark and New York, along with several photographers to capture the day's events. This was the Klan's coming out, and they intended to put on a show. The day's events began with a parade to Muller's church and would culminate at the beach with a grand cross burning and induction ceremony.

The parade began at 9:00 a.m. with four mounted Klansmen leading the parade, followed by another carrying a four-foot burning cross. Then came a brass band and, finally, the man everyone wanted to see. Sitting in an open-top car flanked on all sides by 4 Royal Riders with their swords drawn, the grand dragon rode slowly to the church hidden behind his white hood as thousands watched. Then the grand councilor of the Ladies of the Invisible Empire trotted past on horseback leading 200 female members of the Klan. When asked, she refused to give her name. It was all part of an intricately planned recruitment attempt. That morning, 5,000 people approvingly waved handkerchiefs and hats at the spectacle that passed them. Over 500 members of the Ku Klux Klan, in full regalia, marched down Richmond Avenue and then Arnold Avenue. Arriving at the church, 109 Klansmen filled fifteen reserved pews. The Klan's invited guests watched and waited to hear the grand dragon speak. After the pastor gave his sermon, the grand dragon walked up to the pulpit, shook his hand and announced, in a thick Texas accent, that the Klan had arrived to protect the "real Americans" in Monmouth and Ocean County from the misconduct of the foreigners.

Later in the day, the event moved to Point Pleasant's beach, where the day before workers had erected grandstands for specially selected attendees to view the induction of three hundred new members. In front of them stood the grand dragon at an altar with a six-foot burning cross next to him and, behind him, three hundred candidates looking up at a forty-foot cross and out to the Atlantic Ocean. As the sun was setting, the grand dragon gave another powerful speech. For many, Prohibition violations were just the pretext to the underlying hatreds that began with the arrival of southern and eastern European immigrants, as well as southern African American migrants. The grand dragon was all too eager to play on those fears. He began:

> *My friends—I am sure you are my friends. The Klan is a most unusual and significant movement of modern times. It is not accident or incidental.*

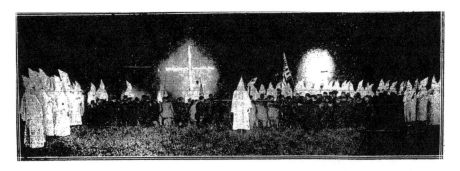

The Ku Klux Klan at Point Pleasant initiating new members. *Paterson Evening News*, July 8, 1923.

[Today's meeting to the public is designed] *so that you may know the real truth.* [The Klan is here to right the wrongs committed by foreigners on true Americans.] *Each year 87,000 girls disappeared in Negro, Chinese, and Japanese dives,* [and the Klan] *is determined to stamp this out.* [Catholics want to brainwash our schoolchildren to obey the pope.] *The Klan* [is] *determined to uphold* [an "American" education] *at all costs and against all odds.*

Sweating and breathing heavily from his fiery speech, he ordered two Royal Riders to administer the Klan oath of allegiance to the three hundred people standing on the beach, and then the forty-foot cross was set ablaze, sending flames leaping high enough for those miles up and down the beach to see it. A new day was dawning on the North Jersey Shore.

The rally at Point Pleasant was the first time the Klan appeared in the area, but still no one was able to see the leader's face. All along the North Jersey Shore, people wondered who their savior was. They did not have to wait long for an answer. Two days later, and unannounced, seventy-eight Klansmen came to the First Methodist Church in Manasquan to recruit new members. Upon listening to Reverend Phillips's sermon on "love and hate," the still hooded grand dragon walked up to the pulpit, shook the minister's hand, turned to the crowd and took off his hood. The secret was out, symbolically and literally. The man was Arthur Bell, a lawyer from Bloomfield, New Jersey. The Klan was a secret organization, but with this one gesture, Bell hoped that the members of the church, as well as those who heard about it, realized they, too, could join. Bell, standing in front, proceeded to inform the congregation what the Klan stood for. We are not "anti-Negro, anti-Jew, anti-foreign born, anti anything," he declared. "We are just Americans."

Arthur Hornbui Bell and Leah Bell. *Courtesy of Aloahwild.*

The Klan was an organization of 100 percent Americans. Blacks could not join because of "the thousands of white girls every year [who] are lost in the black dives of the country." "Jews are not allowed because they do not believe in Christ," and "Catholics are not allowed because the constitution is Protestant, the entire country is Protestant." Bell stressed that the Klan was

merely standing up for the "lost influence" of American white Protestants. For any white Protestant American watching the country change dramatically, the Klan seemed like a perfectly legitimate solution.

Even so, recruiters worked hard to overcome the attacks fired at it. In 1921, the *New York World* ran several scathing stories denouncing the Klan's leadership. The founder of this second iteration of the Klan, William Simmons, dreamed of creating a national organization of united Protestant Americans, but in 1923, the outlook for the Klan was bleak as it attempted to spread out from its southern birthplace. Nevertheless, the organization had come a long way since its founding.

On October 15, 1915, William Simmons stood atop Stone Mountain several miles outside of Atlanta. Alongside him were thirty-four "charter members" who would help build the invincible empire into a nationally recognizable organization. Beneath a fiery cross, burning bright into the night sky, the thirty-five men stood knowing that their symbolic message—the Ku Klux Klan had returned—was sent. But the real work of gaining new members had just begun. By 1921, the Klan had organized itself in New Jersey, with its headquarters at 837 Broad Street in Newark and field offices in Hoboken, Morristown and Camden. Dr. Orville Cheatham was King Kleagle and, upon announcing the opening of a Klan headquarters in New Jersey, told a *New York Times* reporter that the Klan's mission for New Jersey was to "uphold the Constitution of the United States, to protect pure womanhood, white supremacy, separation of church and state and the upholding of law and order." The new message was exactly what the people on the North Jersey Shore wanted to hear.

Even so, infighting at the Klan's national headquarters in Atlanta prevented any further advances by the Klan. When Hiram Evans, a dentist from Texas, took control of the national headquarters in Atlanta, he sent a lawyer friend from Texas to New Jersey. Arthur Bell moved to Bloomfield, where he immediately began organizing recruiting events by attacking the supposed criminal acts of foreigners. But the people of the North Jersey Shore were also concerned with the shift in youth morality. For them, the Klan seemed to be the only organization attempting to do anything about the youth running amok. One Klansman wrote of the youth culture, "Now a boy will drive up in his car, blow his horn and the girl will come running out… if her parents…ask where she's going, this is what they get, 'none of your business,' and away they go." As Fredrick Allen observed, parental control was waning because of the automobile. Towns and cities passed new laws, but something else, something more proactive, was needed. One Klansman

author claimed that "lack of control of parents over their children" led to the "most deplorable results." Imperial Wizard Simmons claimed the youth were being "submerged in a sea of sensuality and sewage." The blame for the youth problem, for Klan leaders, rested solely on women not living up to their responsibilities. Men, too, were at fault, but it was because they had not controlled the women in their lives.

Men, be it husbands, brothers or fathers, were expected to exercise control over the women in their families. Men in the Klan lived by a code of masculinity that expected them to marry and provide for their families through a code of honor, sometimes referred to as chivalry. The code dictated that each Klansman protect the virtue of American women. Nancy Maclean in her book, *Behind the Mask of Chivalry: The Making of the Second Ku Klux Klan*, observed that a man's honor historically meant his ability to control the sexuality of women in his family. Women, the stitch that held the fabric of society together, were pressed to conform to Klan ideals of subservience. Elizabeth Tyler insisted that a real danger existed "unless there is some strong organization constantly preaching that women's place is in the home." Imperial Wizard Simmons took up her warning, declaring, "Citizenship for our young American women includes the essential duty of motherhood...sometimes five or six children...and those who reject childbearing as a burden needed a socializing education."

The Klan insisted on "purity" of its female members and its enforcement by the Klan's male initiates. Imperial Kludd (Chaplain) Caleb Ridley from the Atlanta headquarters impressed on the male members of the Klan that their job was "to make it easier for women to be right and do right," thus preventing young men from going astray while in the backseat of a car with a reckless young woman. That meant providing for their women and the women of the community. The Knights of the Ku Klux Klan of Keyport lived up to their obligation by donating twenty-five dollars to Mrs. Hubbard after both of her young boys drowned in Matawan Creek. The Klan feigned benevolence always, though they pushed for Protestant dominance.

Their ultimate goal was reclaiming Long Branch from immigrant tourists. As the summer of 1923 continued, the Klan demonstrated their superiority by marching though the streets of Long Branch. A procession of seventy Klansmen, a meager number compared with other events, filed through the city on their way to Asbury Park during the last week of June 1923. Carrying two large American flags and a large burning cross, they were cheered along by an estimated five thousand spectators lining the route. The parade concluded in the Asbury Park

KLOTHES **K**LEANED **K**WICKLY

The Valet System

Cleaners, Dyers, Tailors

Deliveries Everywhere

612 MATTISON AVE.

Tel. A. P. 4040

Advertisement from the *Asbury Park Evening Press*, July 6, 1924.

Methodist Episcopal Church, where the pastor, Dewitt Clinton Cobb, greeted the men, declaring that "such an organization was badly needed in America." Cobb, a former chaplain of the New Jersey State Senate, turned to the journalists and onlookers in the church and continued, "[I wish] heartily there were a great many more Klansmen." Up and down the North Jersey Shore, Methodist ministers praised the Klan. With the church's sanctioning, more and more "proper" Americans flocked to the organization. From all over the North Jersey Shore, anyone who wanted to combat the conditions unfolding in front of them sent in their ten-dollar initiation fee and donned a white robe and hood.

By the end of July, the Klan had initiated nine hundred Knights into its ranks. In August, the women's Klan came to Monmouth County. On the evening of August 18, 1923, seven hundred women gathered in a field

in Allenwood. The women formed into a square in front of a sixty-foot burning cross. Around them formed another circle of robed members of the Klan. From outside the circle, Mrs. Bell, the leader of the New Jersey women's Klan, walked in, trailed by four women, one carrying a burning cross, one dressed in white robes, one dressed in blue and one dressed in red, followed by a woman carrying a Bible over her head. Mrs. Bell administered the Klan oath, establishing the women as members. That same night, the Klan made its presence known in Belford when a cross was set ablaze as a "large crowd" looked on. By the end of the summer of 1923, recruitment events were so successful that the Klan could call upon thousands of newly minted members.

Many people joined the Klan because of Prohibition. It was the constitutional measure aimed at preventing the "heathens" from destroying the American way of life. The Eighteenth Amendment was law and had to be followed. Yet it seemed like every immigrant or young person refused to obey the greatest American document, the United States Constitution, creating an endemic problem of crime. Corruption, auto theft and drunk driving played themselves out almost daily. Tourists who traveled down the shore by car eventually had to return home except, in many instances on their return trip, they were intoxicated. The editor of the *Red Bank Register* wrote of the problem: "There are dangers enough on the roads…automobilists who patronize bootleggers are not the sort of men to be let loose in their 'devil wagons,' their place is behind bars." The danger of a drunk driver was all too real for Alexander Gazzole, an elderly store owner from Keansburg, who was walking home to Keyport around two o'clock in the morning when, without warning, he was struck and killed by two apparently drunk men. Another incident occurred when six Jersey City men, after spending most of Saturday evening drinking, left Keyport with Francis Dourham behind the wheel. The men did not make it far before crashing into two other vehicles in Matawan. After the police arrived, they arrested all six men for being drunk and disorderly. Drunk driving was so pervasive during the summer months that the editor of the *Red Bank Register* again wrote a column about it. "A thief is not as great a menace as a drunken driver," he concluded. "Hardly a week goes by without a drunken bum being sent to county jail."

The area was shocked to read in the paper that three Kearny police officers, after spending the evening drinking in Keyport, hit and killed a Jersey City woman visiting for the weekend while she walked on the side of the road. The three men never stopped, and later they were taken into custody in Kearny.

The new breed of criminal, the bootlegger that so many came down the shore to visit, cared little for the people of the North Jersey Shore or their property. Hijackings and the limited possibility of an honest police officer or Prohibition agent arresting and seizing a bootlegger's cargo created a demand for undistinguishable vehicles that could easily pass by even the most observant hijacker. Numerous motorists would find their automobiles missing when they came to retrieve them. Mr. Garrison was just one unlucky victim whose vehicle was stolen and later recovered in Newark. Mr. Rapp of Keyport was another unfortunate person to have his car stolen. The police later found the car in Elizabeth. Mr. Giles had his car stolen in Red Bank and later recovered in Langhorne, New Jersey, near Philadelphia.

Most disturbing of all, the thing that led most into the ranks of the Klan was the influence bootleggers had on local governments. Corruption was nothing new to the North Jersey Shore. Long Branch was dotted with illegal casinos. A reporter for the *Asbury Park Evening Press* toured the city in August 1921 and found that Long Branch was a "veritable Monte Carlo." Miraculously, when the Long Branch police visited the same establishments, along with a reporter from the *Long Branch Daily Record*, they were unable to find any such evidence. Even Asbury Park was not immune, although its paper pretended as such. The boardwalk, a lucrative location for any business and controlled by the city council, was ripe for patronage and kickbacks. Now that Italians and Jews began to influence local governments, the natural order of things was being disturbed, threatening any chance that Protestants along the shore could restore their power and morals on the area.

The Klan decided to attack where its power was the strongest. Its target was the mayor of Asbury Park, Clarence E.F. Hetrick, "the hero of the West Side." The Anti-Saloon League had printed an eighteen-page pamphlet accusing the mayor of taking bribes from bootleggers and gamblers, although none of it could be proved. When the Klan learned of his plan to hold an invitation-only event for ninety-eight local businessmen at the Deal Inn, they knew it would be a perfect time to strike. "Famous for years as a rendezvous for winter residents and summer visitors," the inn was perfectly situated to benefit from the Reinfeld syndicate. The group added to its illegal business of selling receipts to customers to establish its own intricate smuggling operation from three oceanfront homes in Deal. Its operation was as simple as it was brilliant. A Reinfeld ship sailed to the New Jersey coast looking for the lights of Asbury Park and then headed just north, where a Victorian home sat with a red light placed in its tower, signaling the trolling ship. Upon its arrival, a small motorboat was sent out to attach a rubber

pipe to the ship, and its contents were pumped ashore. The system allowed for as much as twenty-five thousand gallons of the finest Canadian whiskey to be pumped into oaken tanks in the basements of three adjacent homes. Niggy Rutkin, a member of the group, said of the ingenious system that it was "much simpler than bringing in little barrels" and "it saved a lot of work and was very efficient." Whether the Klan knew of the operation is unknown, but they did know the Deal Inn's reputation and knew this would be the perfect time to strike.

As the ninety-eight businessmen dressed for the night's event, the Klan began orchestrating its response. Attorney and Klansman Joseph Turner conspired with Walter Tindall, the man who became the Klan's eyewitness to that evening's affair. Walter Tindall was a small business owner in Asbury and resident of the Methodist stronghold of Ocean Grove. A printer by trade, his business was foundering and money was tight. He had bounced a check three days before to a man known to be attending that night's festivities. Joseph Turner also had an ulterior motive. He had been Hetrick's political opponent in the last mayoral election and had lost the bitter fight after Hetrick had done the unthinkable: court the West Side vote. Both men saw their chance to get even. Tindall claimed that night the Deal Inn shuttered its windows and locked its doors, and in front stood two Asbury Park police officers guarding the drunken "orgy" that took place inside. Local businessmen got so drunk that "they could not get off their chairs," while "semi-nude women" danced and paraded through the inn. Tindall remembered in particular one nude woman sitting in Mayor Hetrick's lap. Within a week, Tindall and another man, most likely Grand Dragon Arthur Bell, filed affidavits with the county prosecutor detailing the events they allegedly witnessed. Asbury was sent into an uproar. Reporters went to Tindall's home only to be greeted by two Klansmen claiming to be there protecting Tindall's "considerably disturbed wife." The next day, Tindall arranged to meet with the press. Arriving in a brand-new touring car with Grand Dragon Bell at his side, the two men explained they planned "to see the charges through to a finish." That Sunday, ministers extolled Tindall and rebuked the city's businessmen. At the First Baptist Church, Reverend MacMurray quoted the Twelfth Psalm and then went on, stating, "The soul of the town is determined by the soul of the people. Unless we are honest, moral and clean, we shall wake up and find ourselves...in hell." Reverend Demaris at the First Methodist Episcopal Church told the congregation he would not read Tindall's charges; they were too disturbing. But they should know the charges are "the like of which, I never dreamed could be written in the Twentieth Century."

Mayor Hetrick responded to the accusations, claiming that neither liquor nor nude women was at the event, and in fact, when he arrived home that evening, he had complained to his wife that the night "had been entirely too tame." The city commission supported him, passing a resolution of confidence for its mayor and businessmen. Furthermore, the commission deplored the actions of Bell and Tindall. The city was split, but the Klan did not care. Through its actions, four months later, the Monmouth County prosecutor ordered the Deal Inn padlocked. It was a victory for the Klan. In 1924, the Klan had many victories fighting bootleggers.

That previous January, the Klan had gone to Highlands Methodist Church. Arthur Bell, along with 100 robed Klan members, stood in front of one of the largest audiences the church had ever seen. The town's population was 1,731; that day, over 700 people packed the church and spilled out into the street, braving the January weather to listen to Bell speak. Standing at the pulpit, he threatened the bootleggers and rumrunners, declaring, "We know the conditions here. We know the rumrunners and bootleggers are buying politicians. We are going to see that it is cleaned up." Neither hijackers, the law nor the police could stop rumrunning, but for rumrunners in the area, the Klan was terrifying, and they immediately convened defense councils and made an act of appeasement. The next Sunday, the minister of the Highlands Methodist Church went around to all of the known speakeasies and collected enough money to finish construction on the church steeple. Even still, bootleggers felt uneasy.

That July, the Klan held parades to express its power and patriotism. Returning to where the Klan began in New Jersey, this time over one thousand members paraded through Manasquan to celebrate Memorial Day. The parade was quickly overshadowed by the Klan's Fourth of July celebration in Long Branch. Several days before the planned parade, two wealthy Red Bank residents, Oliver Frank and James Jones, purchased the former Monmouth Racetrack, known during the time as Elkwood, from Walter Lewisohn for $85,000. The purchase totaled 140 acres of land, a large guesthouse, a dance hall, the racetrack and various other buildings, more than enough room to entertain the large number of people planning to attend the festivities on the Fourth.

When the day arrived, over 25,000 people were present. An estimated 7,000 to 8,000 Klansmen and Klanswomen marched along Broadway as airplanes flew overhead and film cameras captured the scene. It was the largest gathering on the East Coast, with groups coming from Delaware, Pennsylvania and numerous national Klan officials. Konklaves from

The Beach, the Boardwalk and a Bed Sheet

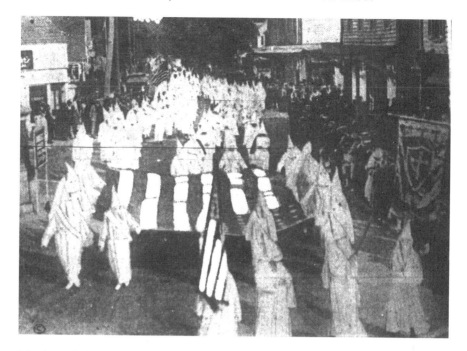

Members of the Ku Klux Klan marching along Broadway heading toward Elkwood Park, July 4, 1924. *Asbury Park Evening Press*, July 13, 1924.

Keansburg, Keyport, Atlantic Highlands, Red Bank, Asbury Park and Long Branch made the strongest showing. The parade consisted of patriotic floats and five bands. Later that evening, thousands of Klan members gathered at Elkwood Park, where 1,500 men and 1,000 women joined the Klan and D.W. Griffith's film *America* was shown.

As the summer continued, the violence only got worse and support for the Klan only grew stronger. In July, a band of hijackers roving in the far western section of the North Jersey Shore moved from robbing bootleggers to attacking innocent citizens. Edward Sanford, a druggist from Matawan, found himself kidnapped from his front lawn. Several men ordered him at gunpoint to get into their car. From there, he was driven to a barn, where he was robbed of sixty dollars.

That same week, hijackers attacked Daniel Walling and Nathan Cohen as they slept together in a truck stored inside the Wallings' family barn in Keyport. Bootleggers had begun offering farmers large sums of money to use their barns for storage. Hijackers, having learned of the news, believed Walling was storing liquor. Around two o'clock in the morning, they struck. Seeing Walling asleep, one hijacker placed his revolver in his face and yelled,

"Hands up!" but then accidently shot Walling through his right cheek. He fell over to the side, grasping his face. They pounced on his sleeping companion next, beating Cohen so severely that both men needed immediate medical attention at the Perth Amboy hospital. Before help could arrive, the hijackers, finding no liquor, escaped.

One week later, another gang struck. Two brothers, Matthew and William Weiler, summer residents of Atlantic Highlands, were driving their delivery truck on the way to their butcher shop in Newark. After passing through Keyport, a Hudson sedan suddenly pulled out from the darkness, blocking the road. Three men jumped out, revolvers in hand, and demanded the brothers give up their money. The brothers had over $1,000 on them, a great score if only the hijackers were more observant. Acting quickly, Matthew tossed the money in the back of the truck as the hijackers approached. When the hijackers approached, they calmly told them they had nothing. Angered, the hijackers ordered out them out of their truck and lined them up on the side of the road facing away as if they were about to be executed as others in the gang rifled through the truck and their pockets. With a vehicle from the other direction coming closer, the gang took off, but their crime spree would not last for much longer.

That same week, the hijackers attempted to hold up Henry Brodt, a truck driver returning from New York City. While he was passing through Cliffwood, the same Hudson sedan once again blocked the road. After searching the truck and Brodt, they realized the truck was as empty as Brodt's wallet and let him proceed. The gang probably never thought the attempted holdup would be their undoing, but Brodt was a nervous man. After the incident, he stopped in Keyport to have a smoke and collect himself. Brodt's employer became worried. He always returned on time, every time. When he did not show, he went out searching for him, finding him standing on the sidewalk in Keyport pale as a ghost. He pressed, "What's the matter?" Brodt responded, "You would be nervous if you had [just] been told to stick 'em up." While the two men talked of what had just happened, the Hudson sedan with the three hijackers passed. Both groups of men surely must have been shocked to see the other. Quickly, Brodt's employer ran the two blocks to the Keyport police station and notified Officer Mason. With years of experience, he told them, let's wait, "the car would probably return through Front Street." Sure enough, a little later John Serba, Fred Grella and Christie Gralo rounded the corner from Broad Street heading down Front Street. Officer Mason stepped in front of the vehicle, weapon drawn, and arrested all three men. At their arraignment, another man came forward stating the men had held

him up six weeks prior. Their crime spree lasted for just a few weeks, and they could show little for their crimes other than the fear instilled in tourists and local residents and a lengthy jail sentence.

In August, bootleggers held a meeting at the Rock Hotel in Seabright to address their growing concern over the Klan's growth and the ever-present hijacker. After a daylong meeting, the area's two hundred bootleggers and rumrunners agreed to raise prices on everything from whiskey to champagne. Now a fifth of whiskey cost between ten and fifteen dollars and a bottle of champagne cost forty dollars. The meeting signaled the end of the war and, for the summer season of 1925, a promise to bring in even larger profits for the bootleggers, if they could only survive the Klan. The gangster strongholds of Highlands and Atlantic Highlands remained certain. Chief Snedeker remained firmly in the pocket of gangsters. Even though business owners complained of their lost profits, many summer rentals remained vacant, and business had been in decline ever since rumrunners and bootleggers took over the town. No one in positions of power seemed to be doing anything about the situation. Desperate business owners even applied for injunctions in an attempt to keep stories "injurious to the welfare of the town" out of the newspapers. But nothing changed. For the people facing the conditions gangsters created in their towns, the only reasonable choice seemed to be the Klan. As a result, the coming summer seasons would be some of the darkest years for the North Jersey Shore.

Chapter 5

THE DARK YEARS, 1925-26

In 1924, Calvin Coolidge became America's thirtieth president. Both Thomas Jefferson and John Adams claim the privilege of having died on the Fourth of July. Coolidge was the only one born on the Fourth of July. A Protestant and self-taught lawyer from Vermont, he was the "purest American." He had no telephone on his desk, nor did he indulge in "worldly delights." Coolidge was frugal, honest, austere, punctual and, above all, conservative and moral. For fun, he sat in his rocking chair on the White House's front porch. For tourists and local residents embroiled in a land of self-indulgence, sex, booze, flappers and crime, he embodied all of what Americans should be. Unlike younger and immigrant tourists who were destroying American values, Coolidge provided the older Protestant residents of the North Jersey Shore with a hope for a return to normalcy. Returning to an America so many from the older generation along the North Jersey Shore longed for seemed like an impossible task. During the summer of 1924, gun battles took place almost weekly. Entire towns had turned away from law and order and the Protestant belief in restraint for a life of crime and excess.

In that same year, the Democratic presidential candidate, John W. Davis, came to Sea Girt in August during the height of the summer season. Denouncing the Klan and Coolidge, he won over few converts. Coolidge declared that "common sense and justice is what the people want," and the people loved him for it. Davis, on the other hand, attacked the Klan, declaring that he stood for "common honesty" where "bigotry, prejudice, or intolerance…must be condemned." In September, directed

by Reverend Cobb, Klansman and minister of the Asbury Park Methodist Episcopal Church, one hundred ministers across the North Jersey Shore instructed their congregations to vote Republican because, as Cobb put it, "there is only one stand for us ministers to take and that is for law enforcement." The election came in November. Davis openly denounced the Klan. Making no statement for or against, Coolidge swept the county. The election of 1924 meant that Protestant common sense would be enforced by the Klan, whose justice would be served upon anyone who did not conform to its Protestant ideals and supremacy. The Klan shifted its attacks from corrupt politicians, rumrunners and Prohibition violators to Catholics, Jews and African Americans.

As 1924 turned to 1925, a battle between a dissenting Klan minister, Reverend George Herman Lawson, and leading members of the Monmouth County Ku Klux Klan began and demonstrated that the Klan would not tolerate dissension. Lawson complained that the Klan mismanaged $40,000 raised for a new Baptist church in Centerville, New Jersey. Klansmen used some of the money to purchase two luxury sedans for Bell. Lawson hoped some of the money would be used for his Baptist church in Matawan. Lawson asked, why does someone need two vehicles? He received no response. Enraged, he declared in the press, "The Klan is an iniquitous fake," and resigned his position, but he did not leave it at that.

Lawson was a foreigner. A Canadian and World War I veteran, he was somewhat abnormal, even for a member of the Klan. He had found God pitching for the Boston Red Sox. After his ordainment, he went to Orange, New Jersey, to minister at the People's Evangelical Church, where he publicly prayed for a bride. In 1923, Ellen Wieber of Keyport finally answered his prayers and walked into his church. The couple and their two adopted children eventually made their way back to Keyport, where they moved into a Craftsman-style home on the corner of Third and Division Streets. The home, one block from Keyport's business district, was located in a densely packed neighborhood. From his home, Lawson constantly sent letters to the Klan demanding an answer to its financial discrepancy. In return, the Klan sent numerous letters telling him to stop his attacks. Nevertheless, the letters kept coming. Fed up, twenty Klansmen, in full regalia, encircled his home, demanding he leave town. The neighbors must have been shocked. If that did not do it, Lawson's response definitely did. Standing in the doorway of his home and holding firmly onto his shotgun with a pistol tucked into the waist of his pants, Lawson responded, "If a Klansman crosses the threshold I'll send him across the Jordan, and he won't go to heaven either!"

The Keyport Klansmen yielded to the threat of certain death from the man everyone knew was not playing with a full deck, but that did not stop them from still asserting their beliefs. In March, they showed up to the African American Baptist Church in the Red Hill section of Middletown. Not surprisingly, that week's services were sparsely attended. The Klan would also visit several other African American churches, reiterating the belief that the Klan was not racist; rather, they just insisted upon an orderly society where all "un-American" races conceded to the white Protestant authority.

Of course, when that orderly society was disrupted, the Klan acted vigorously to return to the status quo. The Klan, by 1925, had grown to the strongest it ever would. That August, the Klan held a national parade through the streets of Washington, D.C., to present its power to the federal government. New Jersey's delegation took two hours to file past. Coolidge, the masterful politician, still refusing to support or denounce the Klan, coincidentally planned to spend the week of the parade at his summer home in Swampscott, Massachusetts. Back home, though, the Klan made a larger impact. Claiming between 60,000 and 100,000 members in New Jersey, most came from the North Jersey Shore. The Klan in Monmouth County was at its height of popularity and power. A contest conducted by the Red Bank Business Association searched for the most popular organization in the town. The contest revealed that the Klan was second only to the fire department, which received 100,286 votes, with the Klan taking 76,348. In Long Branch, the home to the new Klan, crosses were burned on or near the homes of Catholics. The African American population hid from sight, and Jews almost unanimously refused to return to Long Branch. The Klan seemed to be winning. Finally, Long Branch was taken back from the "un-American" tourists.

The Klan's enemies took steps to protect themselves. In Red Bank, an anti–Ku Klux Klan organization started a chapter. Claiming several hundred members, the integrated organization of Jews, African Americans, whites, Catholics and Protestants attempted to reveal the names of those who hid themselves beneath the white hoods of the Klan. In Long Branch, three Catholic nuns from the Start of the Sea Academy watching the 1924 parade recognized one man dressed in full Klan regalia: it was their iceman. Quickly, word spread, and orders ceased from the academy as well as several other institutions. It made no difference. Try as they might, their actions proved futile. The Klan was simply too strong for the anti–Ku Klux Klaners.

Nothing seemed able to stop the white tide of the Klan. In Trenton, Klansman Basil Bruno, a member of the New Jersey House of Representatives and pharmacist from Long Branch, presented a bill requiring all public

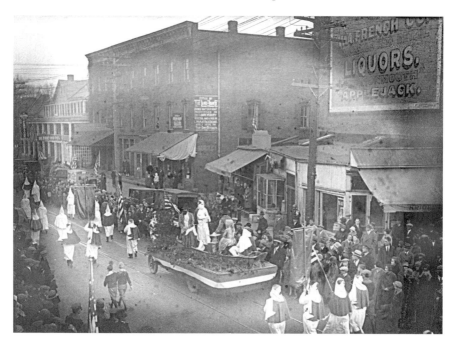

Members of the Ku Klux Klan marching along East Front Street in Red Bank. *Courtesy Dorn's Classic Images.*

schools to read passages from the New Testament. While working from their new headquarters at Elkwood Park, the Bells added a new addition to their repertoire of weapons to maintain law and order. In February, workers erected a radio tower, allowing all with a radio to tune in to daily broadcasts from the WKKK and listen to the addresses and directions of Klan leaders.

The only one speaking against the Klan and getting a response was Lawson. On June 18, he went to Keansburg to give a lecture titled "Kan the Klan." Presidential candidate John W. Davis did the same, but from the protection of Sea Girt. Almost ten miles from Ocean Grove and over thirty from Keansburg, it was just far enough to prevent the Klan from organizing a fiery response. In Keansburg, however, nothing held them back. Eight hundred hooded and robed Klansmen and women appeared at Macdonald Auditorium on Main Street. Lawson planned to speak on the question of whether the Klan was 100 percent American. For two weeks, posters advertised his arrival. Over the airwaves, the WKKK reminded its listeners of his arrival. When he appeared, members of the Klan were incensed. From the moment he began his lecture, the crowd "hissed and booed." Lawson described the members of the Klan as "a gang of freight car thieves,

rum runners and stool pigeons." It took the strength of forty state troopers, county detectives and local police to hold back the crowd. If journalists were not there, he surely would have been killed. But Lawson finished his lecture, and the police escorted him home.

With only Lawson denouncing the Klan, little prevented them from forcing their morality upon the larger tourist population. The Klan's next target became the newly opened African American beach known as Barrett Beach in Port Monmouth. Lauded as the summer resort "where there is no color line," the 1,700 feet of bay-front property provided African Americans with a place to vacation without fear or supervision. The year prior, both Atlantic Highlands and Keansburg decided to open some of their summer attractions to African Americans. In Keansburg, after twenty thousand African Americans spent a "pleasant" afternoon in the town, the mayor and town council decided to allow "colored citizens" full privileges to the amusements on Thursdays as long as "colored citizens cooperate with the mayor and council and endeavor to check bad actors." The town council picked Thursdays because on Wednesday nights fireworks were set off and on Fridays, nothing on the boardwalk cost more than a nickel. Thursdays were always lacking in attendance. In Atlantic Highlands, which was reeling from a drop in tourists ever since bootleggers took over, a similar concession was made for African Americans. Town officials allowed them to visit the Atlantic Amusement Park on Fridays. Only in Long Branch could Catholic and Jewish tourists vacation freely, but African Americans had no place to call their own.

Barrett Beach was the answer. Only there could African Americans truly be free to enjoy themselves. The *Red Bank Register* declared that with the new beach, "the largest number of summer residents Port Monmouth has ever seen is expected." The prediction proved true. Middle-class African Americans from northern New Jersey and New York City traveled to the place where the Duffin's Band of Red Bank played jazz late into the evening, entertaining throngs of dancers made merry from free-flowing booze. On the beach, patrons relaxed under the sun and bathed in the calm, refreshing bay waters, and the concession stands sold southern-style cooking. The resort was complete with a restaurant and ballroom—everything one could imagine. The beach was an oasis, but for real estate agents from the neighboring town of Keansburg, it was a nuisance. The Klan eagerly took up the fight. Over their radio, they broadcast a clear message that Barrett Beach could not exist.

What exactly was said that provoked residents of Keansburg and Belford, the two neighboring communities, to accost the African American

tourists for several weeks was meticulously recorded and printed by the African American newspaper the *Echo*. But some time ago, someone or some group of people decided to black out the historical record. What is left is just the actions of the citizens of Belford and Keansburg. For weeks, summer residents at Barrett Beach reported that the "muttering threats" were growing more brazen and frequent. African American tourists became increasingly concerned over their threats. On July 1, members of the Belford Klan marched down Broadway to the Belford Methodist Church, where they discussed how to remove the beach from the North Jersey Shore. For all of July, white residents and tourists yelled and cursed at the black tourists. Events finally climaxed on the evening of Friday, July 31, 1925. White residents felled a large tree and lashed it into the shape of a cross. They then covered it in oil-soaked rags and lit it for all to see at Barrett Beach. Employees quickly tried to hide the evidence, burying the burned cross early the next morning, but the message was sent. The next day, hundreds of tourists packed up their things and left.

By the end of the summer, the Klan had taken back Long Branch and prevented Barrett Beach in Port Monmouth from becoming a success. In November 1925, Atlantic Highlands was to vote for a new mayor, and the Klan's nemesis, retired police chief Snedeker, planned to run. Opposing him was the former postmaster and Republican Charles R. Grover. It was a bitter fight the Klan could not afford to lose. On Election Day, when the news came that Snedeker had lost, the Klan was jubilant. They celebrated by burning a cross on Tillotson's hill in Navesink, overlooking First Avenue in Atlantic Highlands, in full view of the Italian section, home to many rumrunning leaders.

Even as the Klan and gangsters ravished the North Jersey Shore, the *New York Times* reported that the North Jersey Shore, "from Atlantic Highlands to Deal, is alive with summer residents." Recent immigrants and African Americans may have stopped coming, but white Protestants still escaped the sweltering heat of the city for the cool ocean breezes of the North Jersey Shore. The people flocking to the beaches enjoyed a youthful optimism. July 1925 was a turning point for the country. In Dayton, Tennessee, a battle of godly proportions, the Scopes trial, was taking shape. The 100 percent Americans

worried more and more about what teachers taught their children and what books they read. In New Jersey, the Klan pushed a bill requiring the Bible be read to all schoolchildren and lost, but in Tennessee, the question of teaching creationism won against evolution. The battles were not so much over religion; rather, they were that of majoritarianism or individualism. The older generation was accustomed to setting the community in order through a sumptuary law, vigilance committee or whatever means necessary— the Ku Klux Klan, for instance. In 1912, President Wilson had won the election campaigning for the rights of the community and allowing them to enforce or enact laws they saw fit. Yet as the youth of the nation spent more time in school learning complex theories and questioned the older generation's morality, the closing years of the 1920s would see a profound shift in American thought.

By the summer season of 1926, the shift was evident. At the Majestic Theatre in Atlantic Highlands, one could view the film "no real American could afford to miss": *America*. In Long Branch at the Strand Theatre, the youth viewed a film "to find out the mysteries of life," and that warned women, "Do Not Marry BLINDFOLDED!"

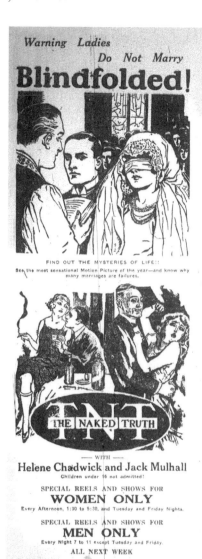

Advertisement from the *Long Branch Daily Record*, July 1926.

The Naked Truth—or TNT, as it was referred to—blew the veil of secrecy off the events of the wedding night in the most "shocking way." While on stage, *Gay Paree* played to packed audiences wanting to see a show depicting the carefree and sexual lifestyles they read about in Hemingway's recently published novel, *The Sun Also Rises*.

Prohibition and the speakeasy had broken down many barriers the older generation had erected to control society. Depicted widely in films, the youth emulated and embraced the immoral "ideas" and sexual happenings supposedly taking place inside speakeasies. The movies narrated facts and offered suggestions to a large audience, especially during the hot summer evenings when the schools had closed for the year, the libraries and churches had closed for the night and the noise and bright lights of a theater attracted those looking for an affordable night's entertainment. Penny shows and nickel theaters were the domain of the North Jersey Shore's youth, where they viewed characters acting and doing things contrary to the ways of their elders. In *Stark Love*, the audience watched Helen Mundy defy her male suitor when he asked, "Would she like to be treated with love and respect…to be taken care of." She responded, "I can take care of myself," a complete contradiction to the Klan and older Protestant ideals of female "purity." In *A Woman of Paris*, after a night of wild partying and drinking, the camera follows a couple into a bedroom, where the audience is to assume the two actors have sex through the symbolic use of a camera cutting to the disrobing of a mannequin on the other side of the room. After a few moments, the camera returns to the couple in bed, where the female actress is hidden beneath a sheet and still presumably naked. *Children of Jazz*, *The Plastic Age*, *The House of Youth*, *The Wild Party* and many others followed similar lines. Films designed for the youth of the nation usually depicted the female character involved with numerous male characters, both older and of a similar age. They showed scenes of joyful crowds drinking, smoking and acting with an indifference to moral customs of older Americans and had a lasting impact.

The sociologist Edward Alsworth Ross wrote in the 1920s, "Young people…are [more] sex-wise, sex-cited, and sex-absorbed than any other generation of which we have knowledge." Ross went on to blame movies for provocative dances, revealing women's clothing, briefer bathing suits and the auto culture where young people could have a place to express their sex-citement. As a result, young men and women now drank side by side and shared cigarettes. Previously, only low-class men smoked; now almost everyone did, so much so that the production of cigarettes doubled from 1918 to 1928. The youth loved the lines used in movies. In *Our Dancing Daughters*, they laughed at one mother's pleas to one of the three men taking her daughter out. "And you Freddie, no flat tires tonight!" The mother warned, "Get her home by twelve or you can't use the car again." The film was so popular that the Hunting Theatre in Red Bank canceled every

other film and showed *Our Dancing Daughters* three times a day for two weeks. In *Hula*, released in 1927, the usual took place—drinking, smoking and partying—but the audience also saw flapper icon Clara Bow, Hollywood's "It Girl" of the 1920s, nude. Nudity was not new to films; however, most previous nude depictions had been of characters in the past or those living in a foreign country. Films viewed by the youth led them to believe that what they watched was normal behavior. One boy wrote, "It was directly through the movies that I learned to kiss a girl on her ears, neck and mouth." A girl wrote that she noticed actresses closed their eyes when kissing and imitated them. The fast pace of romances convinced youths that kissing and petting took place earlier in relationships than they had ever previously occurred.

Schooling also did its part. The youth embraced new theories that questioned the old morality. Sigmund Freud presented the greatest threat to the old stock with his theories of sex. Frederick Lewis Allen wrote in 1931 of the situation, after being filtered through the successive minds of interpreters and popularizers. Phrases like inferiority complex, sadism, masochism, Oedipus complex and Carl Jung's Electra complex began being discussed. Proper mental health became a worry for those who knew of psychology. Maintaining it required an unrestricted sex life. The youth shunned the ideas of their parents, who grew up in the age of Victorian innocence. But what caused such a dramatic shift in 1925 was that the "civilized minority" joined the youth. Older Americans—educated in the nation's universities and individualistic in nature—facing the threat from the Klan and its moralistic members forcing their principles on the larger population come hell or high water, forced their hand. The fields of sociology, psychology, geology, business and scores more began being taught more in the nation's universities. By the 1920s, programs had evolved enough and spread across the nation to such an extent that their influence could be widely felt. With this new knowledge, the new educated elite entered positions of authority in the government and had an immediate impact on the North Jersey Shore—and just in time.

Chapter 6

"I LIKE TO HAVE A MARTINI"

John J. Quinn, the thirty-two-year-old prosecutor of Monmouth County, became the beacon of hope for many who were tired of the division in the county. People wanted to drink, but they also wanted the law upheld. The Prohibition problem was not one of "true" Americans protecting the virtue of lady liberty from the un-American foreigners; it was a problem that could only be solved with unbiased and diligent police work. For years, government forces, be it local, state or federal, refused to battle the problem of corruption. As a result, the criminals controlling the illegal liquor business could always stay one step ahead. The corruption situation fostered a polarization of political forces where the most intransigent right wing politician found very vocal support. However, a large majority did not support their methods. The North Jersey Shore's moral minority may have been the most politically active in the buildup and during the first several years of Prohibition's history, but as the decade closed, the area saw a monumental shift in tactics. Quinn, with his team of young energetic prosecutors and detectives, set out to save the county from gangs of moral crusaders and bootleggers and give voice to the North Jersey Shore's moderate middle.

Helping him was the appointment of a new assistant secretary of the treasury. Retired brigadier general Lincoln C. Andrews acquired control of customs, the Coast Guard and the Bureau of Prohibition, severely undermining the power of Roy Haynes, commissioner of the Bureau of Prohibition and sycophant of the Anti-Saloon League's leader, Wayne Wheeler. Wheeler used his influence not only to have Haynes appointed but to design the Volstead Act as well. His insistence that Prohibition agents be free from the constraints

Lincoln C. Andrews, assistant secretary of the treasury in charge of Prohibition enforcement. *Courtesy Library of Congress.*

of the civil service created a situation where most became corrupt. In 1920, when the Bureau of Prohibition was created, Wheeler's plan created 2,000 positions where all an aspiring agent needed was the endorsement of an ASL member or a politician to obtain the position, leaving the bureau wide open to corruption. Wheeler insisted that only $3 million was needed to effectively enforce Prohibition. In comparison, the FBI in 1920 had a quarter of the number of agents, 579 in total, and still required a $2.7 million congressional appropriation to perform its duties.

Mabel Willebrandt, deputy attorney general in charge of Prohibition enforcement from 1920 to 1928, asserted, "Rumrunners and bootleggers were less responsible for the prohibition mess than the corrupt, hypocritical system that battened onto them." Everyone knew it, too. In August 1922, after raiding places in Asbury Park where one man shot at Prohibition agents, twenty agents stormed into the St. James Hotel in Long Branch. Pulling people out of their beds in the early morning and forcing the hotel's six hundred guests to stand outside in the street dressed in only their nightgowns,

agents tore apart rooms and luggage, creating a lasting impression. The Long Branch police came to quell the angry crowd from rioting, yet somewhere in the melee, a fight managed to break out between a Prohibition agent and a hotel guest. The police responded quickly by arresting the agent. The next day, as reporters came looking for a story, one man described the actions of the Prohibition agents as "comic opera bandits," while John Davis, returning from the police station, told the reporter that he had just finished filing a complaint that the agents stole $210 after raiding his hotel, the O'Mallery.

Outlook magazine revealed how extensive corruption among Prohibition agents had become. During an interview, Charles L. Carsake, a former Prohibition agent, revealed that bootleggers and rumrunners offered him thousands of dollars a week to "look the other way" as their booze-laden trucks passed by him. One brazen bootlegger even offered him a bribe while standing in a district attorney's office that would have almost doubled his $2,300 a year salary. Conditions were so bad that when he tried to make arrests, he would receive orders from higher ups he was needed elsewhere. "About half my time was spent traveling from one point to point for no particular reason," Carsake told the reporter.

Under Lincoln C. Andrews, all of this was to change. Andrews reorganized the Bureau of Prohibition into twenty-two distinct districts, with an administrator controlling each district. Newark, New Jersey, became headquarters to a district covering all of New Jersey and into eastern Pennsylvania, and retired colonel Ira L. Reeves was put in charge of the district. One of Reeves's first acts as administrator required all Prohibition officers patrolling the state's highways to wear dark blue uniforms with large brass buttons to prevent any confusion about whether an agent was a hijacker. Andrews even took the extraordinary step of requiring all agents to abstain from alcohol. The bureau also had a new mission. No longer would it bother going after restaurants, hotels and road stands; now it would primarily go after large-scale smuggling operations. As part of the new strategy, customs officials offered informants living in towns where rumrunning was rampant 25 percent of the profits from fines and sale of any confiscated property from tips that led to the apprehension and seizure of rumrunners and their cargo.

The strategy worked almost immediately. An informant tipped off authorities to the collusion of Coast Guard men and bootleggers in the Asbury Park area. Prohibition agents arrested eleven officers and enlisted men from the Avon Coast Guard Station and two Avon police officers after twenty-seven cases of recently seized liquor disappeared from the Avon police station and found its way to a local speakeasy. A similar incident happened at

Keyport Town Hall. Sixteen cases of liquor seized from a local speakeasy that afternoon and brought to town hall inexplicably disappeared that evening. Try as they might, the officers of the Bureau of Prohibition could not break the stranglehold that bootleggers had over the northernmost part of the North Jersey Shore. Keansburg attempted to placate outside observers by declaring "war on rumrunners." Borough manager John E. Wright instructed police chief Charles A. McGuire to do everything possible to prevent ships from landing liquor on the beaches of Keansburg. Apparently, McGuire and his police force were not too imaginative. The only solution they could find was banning crime reports from the newspapers. In reality, the two men kept taking bribes furnished by Lillien and his criminal syndicate.

Where Reeves did not go, Quinn did. His county detectives, led by lead detective John Smith, actively hunted out the not-too-hard-to-find speakeasies all over the North Jersey Shore. The first strike occurred in Union Beach, near Keansburg. County detectives visited numerous locations, from an ice cream parlor to a grocery store, finding liquor at all of them. Three weeks later, the same story played out. This time, the raiders visited fourteen places in Long Branch and West Long Branch. Once again, the Siciliano family turned up on the wrong end of the law. This time the eldest son had taken over the business after his father, Paul, was arrested along with his wife in Asbury Park after Paul's wife, Theressa Siciliano, killed Paul's mistress, Mary Nicolini. The raiding party continued its push, heading farther south into Asbury Park this time and uncovering its largest finds to date. During a long and successful day, the detectives raided twenty-four places throughout Asbury Park.

Part of the detectives' campaign during the raids of 1926 was to single out the most notorious violators. In June, raiders visited the infamous Deal Inn, reopened and continuing its illegal ways. On the busiest day of the week for the inn, Saturday, with all of its tables occupied, the men burst through the doors, warrant in hand. In no time, they uncovered three hundred quarts of whiskey and, something new, two hundred quarts of beer packaged in individual bottles. Beer was unusual to find. Gangsters considered it a low-value product because, unlike liquor, it required local brewing. One could not simply ship thousands of cases of beer from Canada or England. Having traveled through weeks at sea and changing temperatures, the beer would have gone bad long before it reached the States. Setting up a brewing operation in the States was possible. Before Prohibition, beer was routinely shipped throughout the country. From 1872 onward, Anheuser-Busch used Louis Pasteur's technique of heat to kill bacteria. Yet producing beer in one centralized location left you open to routine hijackings, and if you were raided, your entire investment

would be lost. What was needed to profitably brew beer was a decentralized system, small enough so that the plants would not draw attention but large enough to turn a lucrative profit. Waxey Gordon figured the problem out and had enough cash from smuggling liquor into the country that he could make it work. Gordon opened a brewery in the basement of the Raritan Hotel, the largest hotel in Keyport, well within walking distance of both town hall and the police station. He also had another brewery in Red Bank, at 197 West Front Street, where the entire basement and first floor were converted for brewing. At 1 Prospect Avenue in Asbury Park, Gordon set up the largest underground brewery in the country.

The system worked perfectly. Quinn and federal agents could only wonder where the beer was coming from. On their way back to Newark, after raiding the Deal Inn, the Prohibition agents decided to stop at the Seacroft Inn in Morgan, just north of the North Jersey Shore. Andrews's reorganization was working. Finally, Prohibition agents were doing their job.

About a month later, they returned to the area, surprising the notorious Silver Slipper of Long Branch. Federal agents and local detectives burst through the doors and headed immediately for the basement, where employees had buried $2,000 worth of liquor. Employees tried to hide what liquor they could, stashing bottles in the stove, in coat pockets, wherever they could, but the raiding party found it all. In case they did not, two weeks later, they returned, again finding liquor in all the usual places. "Pasty" Pembarar, a well-liked restaurateur, was not let off so easily. He was arrested and fined $2,000.

With so many speakeasies shut down, the police now had to contend with an explosion in home brewing and distilling. The common tale blamed Prohibition violations on immigrants; however, it could not explain away the corruption, nor could it withstand the widespread development in home brewing as more and more speakeasies were shut down. The moderate middle was finally speaking up by ignoring the law. U.S. corn sugar production increased 470 percent from 1919 to 1929, from 157,275,000 pounds to an astronomical 900,000,000 pounds a year. Corn sugar was to the home brewer what vodka is to the drinker. Odorless and producing no ash, it was the perfect product for the homeowner to produce his own liquor. Even the Methodist stronghold of Ocean Grove was not immune to the shift in Prohibition violators.

On July 14, 1927, John Smith and his men arrived to the two-story residence of S.R. Furoillo at 142 Heck Avenue, just blocks from the town's grand auditorium, where two years prior Leah Bell and the Klan came and gave a last-ditch effort to save the area from the perils forced upon them by the Catholics and Jews. Upon searching Furoillo's home, detectives

uncovered a five-gallon can of raw alcohol and several "mixers" used to make, gin, brandy, cognac, whiskey and wine. They were not the highest quality drinks, but without any alternative they would suffice.

In 1926, all across the country, the Klan was breathing its last breaths. As it had in 1925, the Klan marched down Pennsylvania Avenue to Fifteenth Street in Washington, D.C., where the procession ended at the foot of the Washington Monument. The parade carried many of the usual Klan emblems: burning crosses, white robed men and women, costumed American heroes, banners and the occasional horsemen. The brass bands still played "Onward Christian Soldier" and "Adeste Fideles," and the New Jersey delegation appeared with an original float, a very pretty, Aryan-looking, "Miss 100 Percent America," holding an open Bible. However, this year the Klan was changing. The New York Klansmen along the parade route extended their right arms out palms down in a fascist-like salute. Whenever someone on the sidelines saluted, the Klansmen returned it. The members of the Pennsylvania procession rid themselves of the traditional white robes and hoods in favor of military uniforms and steel helmets, and they carried wooden batons.

They resembled Mussolini's Blackshirts more than they did Americans. Militant patriotism became the new proactive method of enforcing Klan ideology. In 1922, Mussolini and his followers marched on Rome and seized power from the democratically elected government. By 1925, he was able to restore economic prosperity to Italy, but as an editor for the *New York Times* noted, "In this country an administration does not get itself unpopular by promoting prosperity, but in this country we do not encourage prosperity by establishing a dictatorship." Americans did not have to look to the government for prosperity; all they needed was a trip down Main Street, where the salesman waited. Coolidge had famously stated, "The chief business of the American people is business." Those believing that the Coolidge statement was too moderate quickly changed it to the more memorable, "The business of America is business." In the New York area, with the presence of a vibrant stock market and the rise of consumer goods, the North Jersey Shore was ground zero for the booming economy and rode the wave prominently, straight to the North Jersey Shore. The *New York Times* wrote, "In unending lines…tens of thousands taxed the capacity of all the railway, boat and bus lines and filled every resort with record crowds."

The Klan was by now a memory. The moral crusade was over. "Everywhere it [showed] signs of dissolution: nowhere are there indications of gain." The Klan lost out to the ever-present consumer and popular culture. In exchange for a bed sheet and moral crusaders, the American people took a sensational

news story where a hero who had conquered a natural obstacle and those who used modern technology in their feat became national figures. No longer were people looking backward for their moral guidance. From this point on, Americans looked to the present, where modernity took precedent.

People openly discussed the Scopes trial. The imperiled town of Nome, Alaska, stricken with the deadly disease, diphtheria, captivated audiences. The people cheered when hearing the news that Balto, a Siberian husky, had come to their rescue just in time. Lindbergh's flight across the Atlantic made him a national idol. On the North Jersey Shore, the trends followed suit. In Long Branch, Madeline Davis dazzled crowds as she leaped from the wing of one aircraft to another, always ending her bold aerial display of bravery with a crowd-pleasing parachute jump. Asbury Park was home to the Ruth Law Flying Circus, performing similar feats. Red Bank also held aerial events, drawing crowds of thirty thousand or more to watch the aviators' daring displays of death-defying maneuvers. Even the Klan's former headquarters at Elkwood Park returned to its racing roots, this time staging the modern event of auto racing instead of horse racing.

Local papers did not have to scour the country for sensational stories to attract readers. The North Jersey Shore and the large tourist industry provided its own kind of stories. The Twin Brook Zoo, a major roadside attraction for travelers passing through the North Jersey Shore, took the headlines for the summer of 1926. The zoo opened just in time for the 1925 summer season. It was the brainchild of Oliver Hilton, who moved his family from Pennsylvania to Middletown, where he created the zoo as a hobby. Schoolchildren and curious tourists marveled at the large array of exotic animals housed at the zoo. From peacocks to wolves, the zoo did not disappoint. The zoo was so popular that Holton decided to invest in a new animal for the summer season of 1926: a full-sized, tan-colored Indian leopard. Six years old and weighing seventy-five pounds, it had come from Singapore in a shipping crate just large enough to allow the animal to lie down. Once it arrived at the zoo, workers decided it was too late in the evening to unload the animal, so they decided to leave it in its flimsily constructed wooden shipping crate with a small air vent in the front covered by only two steel bars. As they closed the gate behind them and left for the day, they noted that the animal seemed overly aggressive but thought it would calm down within a few days.

The next day when the workers came to look on the leopard, they were shocked. The shipping crate was turned upside down, and the steel bars were pushed out. The leopard was gone. Quickly, the alert went out over radio stations from New York City to South Jersey: be on the lookout for

a dangerous animal resembling a large dog. Everyone with a rifle showed up to hunt the animal. Reports declared, "The leopard is mean; he hates human beings." Papers across the country carried the case. From the *Daily Northwestern* in Oshkosh, Wisconsin, to the *Star* in Anniston, Alabama, the entire country wondered what had happened to the leopard. Hunting parties made up of state and local police, local farmers and adventuring tourists fanned out across the North Jersey Shore. Margaret Ellison, the eight-year-old daughter of a farmer living near the Brookdale Farm, ran home and told her father she had seen "a big white dog with yellow spots on it." Thinking it was the leopard that she had seen, her father quickly called the police. By midnight, the posse had descended upon Brookdale Farm. Searching with flashlights and headlights, they were only able to find some tracks around the barn, but not the leopard. Remaining optimistic, one of the hunters declared, "The leopard is cornered. We will bring it down within a short time."

He was wrong. The leopard had moved on. Wild reports came in, from the Beacon Hill Golf Course near Tollotson's hill in Atlantic Highlands to miles away at Hendrickson's Farm near Keyport. Hendrickson swore to the police that the leopard and his terrier Jimmy had "passed the time" playing together before the leopard disappeared again. With a reward of $500, anyone with a gun took off into the woods in search of the animal. The situation became so out of control that the *Bluefield Daily Telegraph* from West Virginia reported that residents "don't dislike the leopard, they dislike the hundreds of bullets that excited hunters are showering about the vicinity." Hunters from all over descended upon the area for the chance to hunt such a deadly animal. Big game hunter Robert Marron from Jersey City and his group brought with them a stuffed leopard similar to the one that roamed the area. Prosecutor Quinn immediately ordered it placed along the highway in hopes of deterring some of the misguided gunfire. It did not help. Hunters still fired indiscriminately at anything looking like the leopard. William Conover's yellow labrador was shot and killed. For several weeks, hunters traversed the woods and fields from Long Branch to Keyport with no luck. Then they and the rest of the nation learned why. The animal had headed miles south to Eatontown, where it feasted on several chickens owned by Frederick Reeves. Posses of armed men swarmed the area for days, but again the leopard eluded capture. The *Red Bank Register* asked, "Where is the leopard?" Hundreds were hunting it, to no avail. Some thought it was continuing south, while others had not the slightest clue and continued to fire at anything. In fact, the animal had retraced its steps and headed back north to more heavily populated towns. Desperate to find a solution to the

dangerous animal roving the countryside, the Department of the Interior sent a package of high-strength catnip in hopes of luring the creature to a place where hunters would finally be able to kill it.

The whole incident became a comical boon to tourism. Tetley's Stationery store in Red Bank placed a "realistic" leopard in its window and sold surprise packages. If a child "found the leopard" in the bag, he or she would receive an eight-dollar prize. The Federal Fur Dying Corporation of New York offered to stuff the leopard free of charge to anyone who caught it. At the fairs and festivals across the North Jersey Shore, leopard displays were all the rage. The Monmouth Baptist Church fair turned one of its sheds into a "leopard cage," and when summer resident Gertrude Ederle became the first woman to swim the English Channel, the elusive leopard came out to greet her.

Hometown hero Gertrude Ederle captivated the residents of the North Jersey Shore and the national press. Her amazing feat stole the headlines away from the leopard for a short while. She was a summer resident of Highlands, where she began swimming in the Shrewsbury River at an early age. By nineteen, she was ready to tackle the frigid waters of the Channel. Residing in New York City with her family during the winter months, Highlands and the North Jersey Shore adopted "Trudy" as one of their own. Highlands declared September 1, 1926, a holiday, holding a parade and ball. Almost thirty thousand people showed up to greet Trudy on her return. Her parade began at the Cherry Tree Farm in Middletown, where she arrived in her new roadster, escorted by a half dozen motorcycle police officers. At the farm, C. Hendrickson presented her with nineteen roses before the procession slowly began its way to Highlands, where thousands awaited her arrival. Along the way, people lined both sides of the road, throwing flowers and waving as she passed. As the motorcade entered Highlands, a fourteen-gun salute went off, one for each hour it took her to cross the channel, and a loud cheer went up. Brass bands, fire trucks and the crowd-pleasing Jack Rossiter of East Orange, dressed as the Twin Brook Zoo leopard, joined the parade. As with every major parade through town, the parade culminated at Kruse's Dancing Pavilion, where that year's winner of the Highlands Baby Parade, Queen Helen Quast, waited to welcome Trudy home.

As fun as it might have been for tourists to laugh at the comical leopard displays, the leopard struck fear in those who had to work on the fringes of towns in the heavily wooded areas. Those unloading rum ships kept a close eye out not only for hijackers but also for the elusive leopard waiting to pounce. Workers building a road in Lincroft refused to return to work, and huckleberry pickers in Colts Neck and Holmdel left bushes full of berries.

Gertrude "Trudy" Ederle greeted by the press as she returns to the United States. *Courtesy Library of Congress*.

The crowd that came out to see Gertrude Ederle. *Newark Evening News*, September 1, 1926.

The only local resident seeming to have benefited from the leopard was Ruth Parker of Eatontown. She found a small celluloid leopard in a surprise package purchased at Tetley's Stationery and won a new doll and miniature baby grand piano.

For three months, the leopard wondered the countryside until a strange occurrence began happening miles away near Island Heights, New Jersey,

William Irons and the Twin Brook Zoo leopard. *Newark Evening News*, October 17, 1926.

at Mrs. Irons's farm. Several of her ducks had been disappearing for weeks. Confused at what was happening to the ducks, Mrs. Irons asked her son, William Irons, to investigate. He found some very unusual tracks, perhaps from an "extraordinarily large fox or raccoon." The thought that it was the leopard never crossed his mind. Noticing that the animal always seemed to take the same path, Irons placed four traps along the path, optimistic they would do the trick. That night, with her son fast asleep, Mrs. Irons awoke to the sound of her dog barking. For three hours he barked and it "got on my nerves," she told a reporter. Fed up, she ventured out, still in her nightgown and wearing only a pair of slippers, to see what was the matter. From behind a bush she heard a "spitting, snarling noise." As she rounded the corner to where one of the traps had been set, the leopard savagely jumped out at her, stopped only by its hind leg in one of the traps. Mrs. Irons fell back in fear. She screamed for her son as she ran back to the house. Awakened by his mother's screams, William, not knowing what had happened, came running out of the house with the family's double-barrel shotgun. His mother pointed to where the beast was, and with one shot, William unloaded both barrels, killing the leopard. It had traveled over forty-five miles from Twin Brook Zoo to Island Heights and devoured over 110 chickens and ducks along the way. The *Newark Evening News* lamented of the leopard's victims:

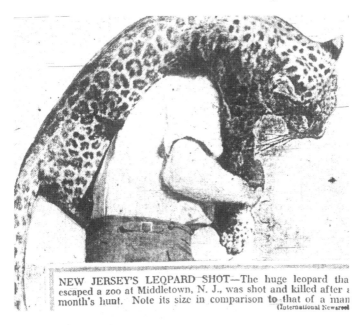

NEW JERSEY'S LEOPARD SHOT—The huge leopard tha escaped a zoo at Middletown, N. J., was shot and killed after a month's hunt. Note its size in comparison to that of a man (International Newsreel)

Unidentified man carrying the Twin Brook Zoo leopard. *Long Branch Daily Record*, October 18, 1926.

From Red Bank clear to Island Heights
Relieved, the natives sleep of nights,
Because no more the leopard prowls
The darkness with horrendous howls.
Pursue their ways again in peace
The pullets, roosters, ducks and geese.
And cynics doubting words recall,
There was a leopard after all.

William Irons, a day short of his twenty-first birthday, returned the dead leopard to the zoo and claimed the $500 reward, making for a handsome birthday gift. On Sunday, Oliver Holton arranged to have the leopard on display, and nearly two thousand people came out to see it. Abram Decker of Red Bank was one of the first to head to the zoo and observe the leopard. "Look," he said, pointing to a mark on the leopard's hindquarter, "that is where I shot the leopard." Other hunters were more humble, staring at the leopard. No one could believe a twenty-year-old mechanic could do what they could not. It was not part of the plan. With the leopard gone, the people once again could wonder about Prohibition. Clearly, it was not working, and many began to ask themselves whether maintaining the law was worth the corruption, crime and general disregard for the law.

Chapter 7

THE HUMBLE DANDELION

In March 1927, Edmund Wilson, a resident of Red Bank and nationally known essayist, wrote of the changing mood in the country. "Drinking has now become universal, an accepted feature of social life instead of a disreputable escapade." He was referring to not just drinking, an occurrence easily overlooked, but extreme drunkenness. The next day, gossip would report "Mrs. So and So disappeared from the party and had been led to the dressing room to be sick." The "married men amused themselves by tripping up waiters," and "Mrs. Such and Such really oughtn't drink so much, because three cocktails makes her throw bread." In the wake of the changing social mood, Wilson meticulously recorded an entire new lexicon of words describing one's drunken state. His partial list begins with the "mildest" stages and progresses to the most "disastrous."

Lit	Canned
Squiffy	Corked
Lubricated	Potted
Owled	Hooted
Edged	Slopped
Sloppy	Stiff
Woozy	Under the table
Half-screwed	Full
Half-corked	Wet
Fried	Liquored

Boiled	Ginned
Jazzed	Organized
Jagged	Featured
Pie-eyed	Lit up like the sky
Glassy-eyed	Lit up like a store window
Bleary-eyed	Lit up like a church
Over the bay	Slopped to the ears
Four sheets to the wind	Stewed to the gills
Loaded	To have a bun on
Plastered	To have a skinful
Soused	To draw a blank
Polluted	To pull a Daniel Boone
Paralyzed	To have the heeby-jeebies
Ossified	To have the screaming-meemies
Passed out cold	To burn with a blue flame
Blotto	

The greatest shift was seen among the youth. Having grown up in a world where drinking was depicted as fun and exciting and helping as their older siblings or parents distilled their own liquor or watching as their elders visited their bootlegger and the next day nursed a hangover, it became quite popular and somewhat romantic to drink. They began carrying flasks and seeing who could get drunk first. A boy who took a girl out was considered a bad sport if he did not bring along liquor for her. It became quite manly to get drunk and pass out. It was something one could brag about for weeks afterward.

The problem with Prohibition had always been enforcement. Wheeler, Haynes and the Bureau of Prohibition thought only a minimal amount of effort and funds would suffice. Yet as those living through the period quickly learned, much more was needed. Still, the federal government did little.

Now it was 1928, and the mood of the country and the North Jersey Shore shifted. Prohibition became a national obsession. The people talked of little else. Books and pamphlets rolled off the presses by the thousands. It was unusual for a magazine not to contain at least one article about Prohibition. Newspapers filled their pages with stories of arrests and shootings, recipes and editorials discussing Prohibition. Prosecutor Quinn, in a lecture to the Holy Name Society of St. Catherine's Church in Spring Lake, discussed the country's changing feelings on Prohibition. Speaking for the moderate middle, he argued that the problem facing the area was the result of the

The Humble Dandelion

"controversies" between Modernists and Fundamentalists. As a result, the youth had gone astray because neither side had taught its children about religion. He told the members of the church that the fault lies with both sides. Continuing, he insisted, "Nobody believes in the kind of prohibition that is now on our statutes." "Years ago people thought it a disgrace to be around a drunk, but now it's quite the thing." Moreover, to those who refused to admit that Prohibition was useless, he said, "they are not men enough and women enough" to realize it and to correct "one of the greatest moral questions ever [to arise] in the United States."

The tide had turned on Prohibition. The people did not care that the government was finally cracking down on prohibition violators. Mabel Wildebrantd quipped, "America's greatest sin today is good humored indifference to existing conditions." For them the experiment had failed. The people of the North Jersey Shore began brewing or distilling their own alcohol. The problem of the youth running amok, immigrants vacationing on the North Jersey Shore and women acting in a sexual manner no longer mattered, as almost overnight vineyards sprang up all over the North Jersey Shore and superseded "all other crops on many farms." A *Red Bank Register* reporter asked a fruit dealer why the demand had increased. "Home brew," he responded. Recipes began appearing in numerous newspapers and magazines. The process was very simple. All one needed was a clean container, "wooden, porcelain, glass or earthenware." Next, one placed ripe grapes into the container and mashed them to release the juices. This recipe from the *Red Bank Register* assured its readers "there is no need to remove the skins, pulp, stems and seeds." All one needed to do was drain off the juice after the "desired flavor" was reached. The whole process did not cost more than $1.50. Home-brew became so popular, one ardent Prohibitionist observed, that Americans were now spending in excess of $186,800,000 on what was fast becoming an American pastime.

The people who were the best at it were Italian. "No class of people make better wine then the Italians," noted the *Red Bank Register*. Plenty of 100 percent Americans bought grapes and learned how to home brew from Italians, but true Americans were also growing their own grapes. The famous potato belt of Holmdel and Marlboro was quickly becoming the grape belt. One of the driest farmers planned to grow 150 acres within a year because "you know they've got to have grapes for sacramental wine for church purposes. Somebody has got to raise grapes for sacramental wine," he told the reporter. With that amount of acreage, the teetotaler could produce 600,000 bottles of "sacramental" wine, making for some very entertaining sermons.

Prohibition was losing favor with the people of the North Jersey Shore. Italians, on the other hand, found acceptance. A 125-foot gold-leafed sign, the largest in the area, directed motorists to the Italian-American Pleasant Inn and Restaurant in Red Bank. The Atlantic Highlands' annual Fourth of July parade, which attracted thousands, for the first time saw the Italian-American Club of Atlantic Highlands win the best float award for its portrayal of the different types of American men. However, what brought Italian Americans and native-born Americans together the most was the "humble dandelion"—the humble Italian dandelion, to be exact. Having a blue flower instead of yellow and much smaller than its native counterpart, when boiled it creates a wine "with a kick like a mule." It was perfect for tourists looking for a bender on the town. "Thousands of persons gathered the crop all across the North Jersey Shore." Treading through grassy fields "today and every other day," their cars lined the sides of roads as even respectable citizens ventured into open fields in search of the dandelion, wrote the *Red Bank Register*. For those not wanting to spend the day trampling through open fields, Dr. Peter Colio, a drugstore owner on Rector Place, and Michael Canzona, a fruit store owner on Monmouth Street, both cultivated and sold the flower. Tourists from New York City came to accept Italians so much that in 1932 they elected an Italian, Fiorello LaGuardia, as mayor. In many ways, Prohibition was the result of immigration. Now, those same immigrants and their culture were bringing about its end.

Meanwhile, the syndicate operating out of Atlantic Highlands and most bootleggers were reaping huge profits. Even though all along the North Jersey Shore speakeasies were shut down, the syndicates working from the area did not rely solely upon the immediate area for business. The North Jersey Shore and, more specifically, Atlantic Highlands served as one of the nation's largest ports for illegal liquor smuggling and shipped liquor as far north as Boston and as far south as Washington, D.C. The large network provided criminals the ability to maintain profit margins even after losing one market. But a resurrected movement would soon threaten even that safety net.

In 1928, the tide was turning on Prohibition. Pierre, Irenee and Lammot Du Pont of Du Pont munitions took control of the Association Against

the Prohibition Amendment (AAPA). Quickly, many leading capitalists—such as Percy Straus of Macys; John J. Raskob, vice-president of Du Punt Munitions and chairman of the Democratic National Committee; Elihu Root, Republican Party policy advisor; and Charles H. Sabin and his wife, Pauline, the first female member of the Republican National Committee—joined on. The AAPA started in 1918 during a time when many of America's wealthy citizens supported Prohibition. Captain William H. Stayton formed the organization and found support from brewers and distillers. Now that Prohibition had removed honest brewers and distillers and replaced them with criminals, the AAPA took on new leadership and a new message. Prohibition was no longer a matter of saving American society. Rather, it had become one of taxes. In 1913, the Sixteenth Amendment gave the federal government the right to collect income taxes. Between 1916 and 1921, taxes collected by the federal government increased six-fold. In a pamphlet distributed to America's highest taxpayers, Pierre Du Pont argued that the repeal of Prohibition would mean a repeal of the Sixteenth Amendment. A report released by the AAPA concluded that New Jersey, New York, Massachusetts and Illinois paid 58 percent of the nation's income taxes. "It is interesting to reflect that if we had not been placed under prohibition… for every ten dollars of personal income tax we pay today, we would keep eight," the author of the article pointed out.

For the criminal underworld, the threat facing them from wealthy Americans did not faze them. Instead, the support the AAPA found among the rest of the country terrified them. Much like the Anti-Saloon League in the years leading up to passage of the Eighteenth Amendment, the AAPA continuously released damning reports on Prohibition. In a pamphlet titled "Scandals of Prohibition Enforcement," the AAPA reported on the widespread corruption that Prohibition had caused. Here are just a few examples:

- Chicago: Indictments were returned against the mayor of Specialville, a suburb, and twenty-four other persons.
- Morris County, New Jersey: The former county prosecutor was found guilty of accepting bribes from liquor law violators.
- Edgewater, New Jersey: The mayor, the chief of police, two local detectives, a United States customs inspector, a New York police sergeant and eight others were found guilty of conspiracy.

In the pamphlet, they described the residents of New York City, the number one supplier of tourists to the North Jersey Shore, as the "most

conspicuous violators" and warned that the Eighteenth Amendment was creating "disrespect" for the law. After its release, the Bar Associations of New York, New Jersey, Detroit, Portland and St. Louis adopted resolutions for repeal. The New Jersey Bar Association, in its resolution, declared that perjury had become "the bane of litigation."

In 1930, the *Literary Digest* conducted a poll asking, "Do you support enforcement, repeal, or modification of the Eighteenth Amendment?" In New Jersey, 84 percent of respondents supported either full repeal or some type of modification. In New York, the feeling was similar: 86 percent favored repeal or modification. Across the nation, people read the AAPA's next damaging pamphlet, "Reforming America with a Shotgun." In it, the association wrote that because of the Eighteenth Amendment federal agents had killed 200 innocent civilians. The *Washington Herald* took the AAPA's statistics further, adding in local and state-level officers, and found that government officials killed or wounded 1,360 people because of an officer's "eagerness to shoot first and ask questions later." For gangsters collecting millions selling illegal alcohol, the changing mood of the country signaled it was time to organize to guarantee that profits would not fall.

In an unprecedented move, a national convention of the country's largest gangsters took place at the Ritz and Ambassador Hotels in Atlantic City from May 13 to 16, 1929. The list of attendees read like a who's who among the criminal underworld. From Chicago came Al Capone. From Cleveland came Moe Dalitz. Johnny Lazia came in from Kansas City. King Solomon traveled down from Boston. Out of Philadelphia came Boo-Boo Hoff and Nig Rosen. New York supplied the largest contingent of Charles Luciano, Frank Costello, Meyer Lansky, Dutch Schultz and Owey Madden. From New Jersey, Joseph Reinfeld and his colleagues, Longy Zwillman and Al Lillien, as well as Waxey Gordon, traveled to the event. The meeting was held atop both hotels in conference rooms free from the prying eyes of the press. Overlooking the boardwalk, those in attendance sat down at the long tables filling the room. The mood was tense. The murder of Arnold Rothstein had occurred just one year prior for unknown reasons. Even more recent was the infamous St. Valentine's Day massacre, which shook up the Chicago underworld.

However, what everyone came for was the discussion of setting up regional "federations." The aim of the system was to create a method to regulate the sale of liquor, from its price to the amount imported. It was a clear violation of the Sherman Anti-Trust Act of 1890, but it was hoped that it would guarantee each federation's control over its area, allowing

them to operate without interference from competing gangs. In essence, the establishment of federations secured each gang's profits if Prohibition was to fall. For New Jersey's gangsters, the agreement was a godsend. The up-and-coming gangster Dutch Schultz was causing much concern. Longtime bank robber Willie Sutton described him best: "He was a viscous, pathologically suspicious killer." A rare German Jew in the bootleg business, he came late to the party but was quickly making up for it. By 1928, he went from being a simple bartender to owning seventeen saloons and breweries. He had become the undisputed "beer baron" of the Bronx and now was moving in on Waxey Gordon's territory. As the meeting ended, all those in attendance agreed upon establishing federations—in effect, putting the organization in organized crime and making the criminal underworld a national organization. The agreement created the five New York City–area Italian mob families that last to this day and gave much of New Jersey to the Jews. But this time, the police kept up with the changes taking place within the underworld.

The police came armed with a slew of new weapons to gather evidence. Prosecutors interpreted and used the law in a multitude of new ways, and police organizations across the nation worked together, sharing information to put an end to the gangsters. Walter Keener learned quickly of the new techniques the government was using to bring down bootleggers. Keener was well known in Highlands and well liked by everyone. Prohibition agents arrested him in 1924 for selling liquor, but that did not stop him. In January 1929, he filled eight orders for "champagne and other liquors" called in from Michael Tilton, Julia Tilton, William Keeler and David Tavern from Washington, D.C. During each phone call, dry agents recorded every word from both parties. In November, the agents struck, arresting and indicting him on charges of failing to pay customs on imported cargo in violation of the Tariff Act of 1922. Their case rested solely on recorded phone conversations. When the government moved to have Keener extradited to Washington, D.C., United States commissioner James Carton ruled that "the government failed to prove that it was Keener" on the phone and set him free. Disappointed, the setback did not stop investigators from bringing down other Prohibition violators.

"Strange men" began showing up all over the North Jersey Shore. In Long Branch, after a three-month undercover investigation that spanned the entire summer, Prohibition agents arrested four men for operating a still and selling whiskey. Just one month later, the agents tried their luck again. This time, they tried to take down the notorious Atlantic Highlands syndicate run by Lillien.

Three agents came to Atlantic Highlands in late September, just as many of the summer residents were leaving. Several months before, the syndicate's ingenious radio system had been found out. While on vacation in Brooklyn, Forrest J. Redfern, the assistant radio inspector in the Radio Division of the Department of Commerce, just happened to be scanning the airwaves for unlicensed operators. As he scanned from one station to the next, he came across a most curious broadcast: "4 RD" followed by "Check 30GLVW OMSIC OBWOK ARK." The next day Redfern contacted higher-ups in Washington. They told him to stay put and record everything he heard. For the next few weeks, he sat at his radio meticulously recording every message while a special team of code breakers, sent from Washington, tried to make sense of it all. When the code was finally broken, the government men were astonished. The messages were from a bootlegging operation spying on the Coast Guard, sending out orders and guiding rum ships past the Coast Guard blockades. It seemed as if the voice coming in over the radio had an eagle eye view of everything the Coast Guard was doing. It did not take long for the government men to figure out where the messages were coming from.

For the men and women standing on the bluff where the syndicate's headquarters was located, things did not seem right. The Coast Guard seemed to be out in force. Washington officials had an inkling that the Coast Guard stations from Sandy Hook, City Island and Montauk Point worked for the syndicate, so they dispatched six cutters from New London, Connecticut, with sealed orders to intercept any small craft traveling through the Raritan Bay area. The news only got worse for the gangsters. Word came from town that three men had just rented rooms in a hotel down the street, and they definitely were not on vacation. Acting quickly, Lillien ordered the recently arrived freighter, the *Shawnee*, to make a hasty departure through the blockade. It was worth the risk. If the ship was caught in U.S. territorial waters, it would mean many years behind bars for all of them. Next, Lillien caught the next train for Canada, hoping to ride out the inevitable raid at the Bronfmans' Montreal headquarters. Before he left, though, he ordered those who remained to rid the house of liquor.

On October 16, 1929, exactly at 4:30 p.m., 130 raiders stormed the syndicate's headquarters, known as the "Mansion," and thirty-four other

places in New Jersey and New York. The syndicate's radio station at 33 Shrewsbury Avenue in Highlands was raided, and Malcolm MacMaster was picked up. In their home at 61 Linden Place in Red Bank, agents arrested Vito and his brother John "Two Gun Johnny" Calandriello. Back in Highlands at 296 Navesink Avenue, the agents surprised Manny Kessler, Morris Sweetwood and Thomas Ross. As agents crashed through their door, another party of raiders stormed the Tuxedo Hotel in Highlands, where the syndicate had established a warehouse. Harold Landauer was there, having just finished emptying the enormous quantity of liquor once held there. When agents appeared, they found nothing, but they still arrested Landauer. The story was the same at Villa Richie at 88 Cortland Avenue in Atlantic Highlands. Agents found no liquor, but Alexander Bergona unfortunately happened to be there as raiders showed up. He was not named in the warrant but was arrested anyway.

At the Mansion, agents made the largest finds. The syndicate had turned the house, formerly owned by Oscar Hammerstein, into a club and a spot to supervise the unloading of their illegal cargo. Three large spotlights used to guide the fleet of motorboats sat affixed to the perimeter of the newly constructed tennis court. In the third-story cupola, telescopes were placed to watch for the Coast Guard and look over the unloading of the syndicate's rum ships. In the basement, raiders found tunnels leading to underground vaults beneath a newly constructed tennis court. No liquor was found, but several machine guns, rifles and pistols were found hidden in one of the vaults. Agents found fifteen people in the Mansion, including Andy Richards, Louis "The Wop" Caruso, Ralph Bitters and the other Ross brother, Samuel. The most important piece of evidence was a little black book that recorded every transaction the syndicate had made in the last six months. Everything from transportation costs to bribes was systemically recorded in it. In the last six months alone, the syndicate had made $2 million and paid out $30,000 a week for protection. Even still, agents did not get the man they truly wanted. Lillien was gone, at least for now.

In the subsequent days, reporters from all over flocked to the area hoping to find a story. What had happened? How could such a large ring of smugglers exist in such a small town? What was going on? They wanted to know it all. What they got was completely different. A reporter from the *New York Times* appeared at the Mansion and found Louis Caruso sitting on the front steps. "Young, blond and clean cut...he was courteous...and open in his conversation." He resembled nothing of what a gangster should look like, the reporter noted. Caruso explained to the reporter that he was merely a

Weapons captured at the Mansion. *Asbury Park Evening Press*, October 17, 1929.

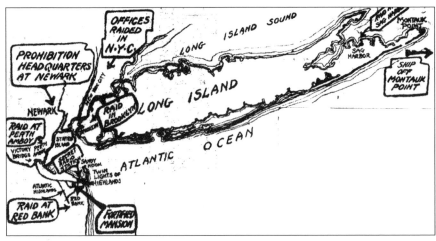

Map of locations raided. *Newark Evening News*, October 17, 1929.

contractor in town and had never seen any illegal activity. He was following the story the gang had planned before the raid. He claimed, "They simply got the wrong house," and, "I've never been called 'Louis the Wop!" To prove agents got the wrong house, he offered to give the reporter a tour of the home, to which the reporter happily agreed. From the attic to the basement, he and the reporter inspected the house. Caruso stopped from time to time, boasting of the "elaborate bathrooms and hardwood floors" he had just installed. In the basement, the men walked through one of the tunnels where agents had found an "arsenal" of weapons. "Come over here and look at it," Caruso asked the reporter. "It is where we are setting the oil tank for the oil burner in the basement." It is curious that the reporter never bothered to ask him about the weapons the agents took from the tunnel. Perhaps he did not want to find himself buried beneath a newly installed oil tank. Caruso continued with the interview, joking with the reporter as they headed back upstairs: "This might [even] be good for my contracting business."

The story was similar when a reporter from Long Branch interviewed the newly elected mayor of Highlands, George W. Hardy. He won the election by a mere five votes. Hardy was not against Prohibition but was definitely against the rumrunners. They had supposedly spent hundreds of dollars to defeat him. When he won, the rumrunners allegedly spent hundreds more for a recount. After the recount, Hardy's plurality increased to six. A close race, the issue clearly divided the town almost down the middle. When a reporter came asking questions of who knew what, Hardy, the pragmatic politician, pretended to be as surprised as everyone else was. The headline of his interview read "Highlands Is Completely Surprised by Big Raid." Hardy insisted that "liquor operations [had] ceased" in 1925. The people of Highlands "are not in league with the illegal operations of any kind." He continued, "Bootleggers can't operate here today. Eight years ago, small speedboats carrying only about one hundred cases were used and they came up the Shrewsbury from Sandy Hook all the time. The bootleggers in those days had just started and most of them never had any money before. So they used to run wild as soon as they made a little money, getting drunk and shooting up the town, but it's not that way today." Yet a quick survey conducted by the reporter found that the people of Highlands "are not unfriendly to the operators." It was going to be a tough sell to convince a jury that the syndicate's members were innocent. Much of what they did took place in the open. Whether the lights were turned off at the ferry terminal or Alexander Lillien was driving though town in his twelve-ton armored car, any lawyer would be hard-pressed to explain the unusual happenings in Atlantic Highlands.

Lillien eventually returned to stand trial, along with thirty-eight others, on charges of conspiracy to violate the National Prohibition Act and the Tariff Act of 1922. The trial was held in Trenton, where the U.S. prosecutor, Phillip Forman, and a cadre of assistant U.S. prosecutors hoped the syndicate's bank records would convince the jury that these men had, in fact, operated one of the country's largest smuggling operations. From the books, Forman was giving a complete view of all those who had worked for the syndicate, and on the first day of the trial he used that information to name who performed what task and detail to the jury just how extensive the syndicate's operations were.

Standing in front of the jury, Forman explained that the syndicate employed thirteen full-time speedboat captains. Herman Black, Edward Bitter, Felix Bitter, James Buff, Harry Buckhorn, William and Joseph Feeny, Joseph Kublis, John Marston, Charles Lee, Ernest Winter, Early Waugh and William Torpus transported liquor from the syndicate's fleet of oceangoing vessels to shore. John Davis, the captain of the *Shawnee*, was the only captain arrested from the fleet, but Forman told the jury the syndicate operated at least twelve more, including a vessel named the *Lucky Strike* captained by William Hannon. He went on to say that James Friday worked as a financier and Joseph Levin, Samuel Levin, Samuel Krivett and Abraham Waxman worked as salesmen from an office just blocks from Times Square at 25 West Forty-third Street in New York City. The Calandriello brothers, bottle makers from Little Silver, opened another bottle manufacturing plant at 265 North Ninth Street, Brooklyn, to handle the large demand. Providing protection for the outfit was Charles McGuire, chief of police for Keansburg. He was taking bribes from the syndicate in exchange for a safe place to land their liquor. Working with Constable Edward Goff and Louis Leonardis, the traffic manager for the Keansburg Steamship Company, the three men oversaw smuggling operations at the Keansburg ferry terminal. Protecting the fleet of trucks and cars used to transport liquor throughout the area was motorcycle police officer Charles Weiner from Elizabeth. In charge of the whole outfit were four men: Andrew Richards, Louis Caruso, Harold Landauer and Alexander Lillien, all from Atlantic Highlands.

Forman laid out each man's alleged role in the syndicate and then turned to bank records, certain the jury would jump to the obvious conclusion that all of the men worked in connection to violate the law. The second phase of the case began with testimony from William Mullin, the Prohibition agent who had tapped the gang's telephone lines and heard discussion about liquor and Canada. Herman Lipton testified next, stating that he pursued two speedboats through Raritan Bay on the night of October 7, 1929,

and after seizing one of them by shooting its captain through the shoulder revealed that Alexander Lillien owned the vessel. Prosecutors were certain there was a connection, but Judge Lyles Glenn struck Lipton's testimony from the record, stating, "The fact that my automobile was found on the highway loaded with liquor would be no proof that I had transported liquor." Assistant U.S. prosecutor Salter quickly retorted that yes, that may be true, but "this is a conspiracy trial and if your automobile was registered with someone else's name and it were shown you paid the repair bills it would prove circumstantial evidence." Salter did not move Judge Glenn; the ruling stayed. It was a critical blow to the government's case. Still, they believed they had enough evidence remaining to show conspiracy.

The syndicate had seven accounts with seven different banks. In Newark, Lillien used the alias Al Silver to open an account with the New Jersey National Bank and Trust, where the gang's higher-ups met to consult business. Max Hassel and Waxey Gordon held accounts at the bank as well, but prosecutors were not aware that John Stamler, president of the bank, had turned his bank over to many of New Jersey's gangsters. Between June 30 and September 30, 1929, Andrew Richards deposited $241,135 using the alias of George Kline in the bank. Then on July 9, Richards again deposited an undisclosed amount of money in the Keansburg National Bank, this time using the name John Clancy. The gang had an account with the Bank of America in New York City, where Anthony Cassino, a driver for the gang, deposited $572,678 between January 29 and June 28, 1929, under the name of Charles Ross. Herman Levin, Joseph Levin and Ed Flanagan also used the bank, sharing an account under the name of George Kruger. Lillien had an account closer to home in Red Bank at the Broad Street National Bank, which he used to transfer money to his account in Newark that he then used to pay a man named Moriarty, a shipping clerk in Canada, $2,000.

As the case continued, the government grew worried. Their information, while detailed, still did not definitely prove that any of the money came from illegal actions. The jury, it seemed, was not seeing the case as they did. Assistant U.S. prosecutor Watts, fearing the worst would happen, produced a check in the amount of $1,500 from Al Capone, the notorious gangster from Chicago. The check was canceled before it arrived to one of the accused, but prosecutors believed it showed a national conspiracy was at work and "would blow things wide open." Prosecutors then went on to theorize that the check was sent to pay for a kidnapping ordered by Capone. In June, prior to the raid, William Elliot, vice-president of the Hobart Trust company of Passaic, New Jersey, was kidnapped and held for six days. What happened

during those six days Elliot never revealed, but he described the men as "Chicago gangsters" to police. One federal prosecutor working on the case admitted the link was "slender," but its potential for revealing the syndicate's operations was tremendous. Assistant U.S. prosecutor Wilkinson encouraged the link as much as possible, stating to the press, "It is no secret that this mob of bootleggers is more or less hooked up with the gang of Scarface, Al Capone." However, back in court the next day, prosecutors dropped the Capone link and continued with the bank account theory. Showing the jury one of the black books where the notation "XL" was inscribed, Assistant District Attorney Watts argued that it was code for one of the bank accounts. The government called Allen Whitney, a cashier from the Broad Street National Bank, and Vice-Presidents John Alvery and Frederick Kuegelman, of the New Jersey National Bank and Trust, to verify that the "XL" theory was correct, along with other accounts. Both men testified that they had seen several of the defendants in their banks depositing large sums of money. Looking over at the jury, they did not seemed swayed by any of the evidence. With nothing left, the government rested its case with little hope for a conviction.

The government's case rested on three facts: the ring operated a fleet of vessels from Canada to the United States; their vessels, directed by a radio station in Highlands, smuggled liquor into the country; and the syndicate maintained seven bank accounts with large sums of money throughout the New York–New Jersey area. The trial lasted three weeks, yet little evidence actually connected the alleged conspirators with their crime. After summation by both sides, Judge Glenn ordered twenty-two of the defendants freed. The government had not proved its burden. As for the other seventeen, the jury took seven hours to deliberate, returning with a verdict that sent the entire courtroom into joyous laughter and applause. All were found not guilty, Judge Glenn declared, as he read the jury's decision. The case took over two and a half years to prepare, and as with Keener, the government had failed. Yet they need not worry. Circumstances out of the control of the government were in motion that would bring the gangsters of the North Jersey Shore and Prohibition itself down.

Chapter 8

O.K. H.B. CROOK

Lillien and the rest of the syndicate returned home to find the country reeling from an economic depression and the criminal underworld in a vicious war. The Atlantic City conference, which was supposed to end the troubles for the New York City underworld, did anything but. Instead, it provided Luciano with the ability to organize an entirely new Mafia and put out of business or kill his competitors. During the final years of Prohibition, scores of gangsters met their end, and control of the bootleg business shifted to Luciano and his second in command, Vito Genovese. Together, they formed a new gang called the Commission.

Before Luciano rose to power, he would have to deal with the two men, Salvatore Maranzano and Joseph "the Boss" Masseria, who controlled the New York City mob. Maranzano and Masseria filled the void in New York City left by Ignazio Saietta after he was incarcerated for counterfeiting. Even so, they never commanded the legions that either Monk Eastman or Paul Kelly did.

In 1904, a Pinkerton detective ambushed Monk Eastman after he tried to rob a wealthy young man who was drunk and "slumming" through Satan's Circus. Fleeing from the detective's pistol fire, Eastman found himself face to face with a New York City police officer's nightstick. Knocked unconscious, he awoke in a jail cell and was later sentenced to ten years in Sing Sing. Without his supervision, his gang floundered and then collapsed. Paul Kelly's Five Pointers did not face the long arm of the law; rather, they were up against the moral crusades of New York City's Committee of Fourteen, an offshoot of

the Anti-Saloon League. Very quickly, the gang, once twelve hundred strong, dwindled to barely thirty as the Committee of Fourteen worked to shut down the city's red-light districts and gambling dens, relieving the gang of its most lucrative income sources. Prohibition brought an opportunity for criminals to reestablish their numbers. Except this time, they had not merely stopped at controlling one city; instead, many gangs were international organizations with interests in many U.S. cities. The only holdup for New York City's Mafia to reap the benefits of the modern criminal business plan was its older leaders. Luciano, determined to let nothing stand in his way, acted.

On April 15, 1931, Luciano invited Masseria to lunch at the Nouva Villa Tammaro restaurant on Coney Island. According to Mafia legend, Luciano ordered the Boss a respectable meal: antipasto, spaghetti with red clam sauce, lobster, Fra Diavolo and a quart of Chianti. After their meal, the two men casually played cards until just before two o'clock in the afternoon. Luciano had worked out that at two o'clock he would get up and go to the bathroom, just before Vito Genovese, Bugsy Siegel, Joe Adonis and Albert Anastasia would burst through the front door with guns blazing. At the prescribed time, Luciano excused himself from the table. A moment later, the room filled with more than twenty bullets; six found their mark. Masseria slumped facedown onto the table. He was dead. Before leaving, the assassins placed an ace of spades in his hand.

With only one older leader left in New York City, Luciano called on his old friend Meyer Lansky to have Salvatore Maranzano killed. Posing as police officers, four of Lansky's men walked into Maranzano's office on Park Avenue. Walking past the guard positioned at the front door, the group of four men entered Maranzano's office. He immediately knew what was happening. As he was springing from his desk to attack, the four men opened fire, striking him four times. Just to make sure the job was complete, one of the four walked up to the lifeless body lying on the floor and stabbed him six times. Luciano hoped his efforts would be the last needed for complete control, but the Great Depression caused the call for repeal to grow louder.

———•◦•———

In October 1929, the stock market began a tumble that did not hit bottom until 1933. On October 1, unemployment stood at 5 percent and the stock market at 383. On October 23, the largest trading day in the history of the

stock market occurred: 6 million shares traded hands and accounted for a loss of $4 billion. There was so much activity that the telegraph operators sending updates of the market across the country fell two hours behind. But the week only got worse. In an "atmosphere of anxiety and uncertainty," trading on October 24 broke new records: 12,894,650 shares were traded, accounting for a loss of $9 billion. Things kept getting worse. The next week, on Tuesday, October 29, forever known as "Black Tuesday," 16 million shares were traded, and for the next three weeks the market continued its landslide until mid-November, when some $26 billion had evaporated and the market had lost 40 percent of its value.

The country was heading for depression. There was still hope though. Depressions had happened before; it was nothing new, and the economy naturally corrected itself. The word "great" still did not precede depression in newspaper accounts. People were worried, but they also looked at America's untapped potential. Markets remained underdeveloped. Consumer products still poured off the assembly lines, and the best example of American potential was utilities. While a full 50 percent of the country was electrified by 1930, another 50 percent still waited. There was hope the country would only need a year or two to turn itself around and begin growing again, especially with a proven leader in the presidency. Americans had the greatest hope with the newly elected president, Herbert Hoover.

Hoover, like Prosecutor Quinn and Colonel Reeves, embodied the ideals of the new educated elite. He graduated from Stanford University with a degree in geology and engineering newly offered by the school. When called upon to feed the starving Belgians after World War I, he succeeded beyond expectations. More recently, he had saved the people of the Mississippi River Valley from catastrophe as town after town was flooded during the great flood of 1927. He worked with military precision commandeering trains and ferries, coordinating with the Red Cross and establishing concentration camps—a phrase still acceptable in the 1920s—fully stocked with blankets, food, medicine, etc. Hoover became America's guardian and rode the feeling all the way to the White House.

Now faced with another tragedy, this time economic, Hoover and Americans believed he was the right man for the job. In his mind, Hoover believed three things would turn the economy around: maintaining wages at current levels, increasing government spending and passing a protective tariff for farmers. In reality, they were arguably the three worst things to do. In November 1929, Hoover increased building programs by $423 million to expand and construct new government buildings, but the sum was not

nearly sufficient to offset any recent loses or spur any increased spending in the private sector. In the same month, he met with business leaders, railroad owners and labor unions to push his agenda of maintaining wages and employment at their current levels. While the idea seemed humanitarian, companies could not contend with the worsening economy while maintaining their employees' wages. Companies drastically reduced workers' hours while others, unable to make payroll, shut down. Even so, the latter two measures were not as disastrous as the Hawley-Smoot Tariff Act of 1930. Designed to protect farmers from international competition, the new tariff raised import duties to their highest levels and signaled to other nations to return the measure in kind, closing off markets for American industry and sending the country spiraling further into depression.

As Hoover unsuccessfully attempted to spearhead business leaders to react to the growing decline of the American economy, the people turned away from the ways of the 1920s. Logic and reason replaced the carefree rebellion of the previous decade. As the market edged lower and lower, so did women's skirts, returning to their pre-1920s lengths. Romance and formality returned. The merry days of the 1920s were over. The AAPA's tax message found many eager supporters along the North Jersey Shore. Struggling hard during the Depression, tourism—the lifeblood of the area—was faltering. From 1928 to 1931, the earnings of the Central Railroad of New Jersey, the train that brought thousands of tourists each year to the area, fell from $22.06 a share to $10.29. Most telling of all was Asbury Park's famous Baby Parade. Each year, hundreds of thousands came to the city for the weeklong carnival, but as the Depression worsened, fewer and fewer people could afford the trip. In 1930, as the Depression was just taking hold, 200,000 people attended the carnival and over 1,000 participated in the parade. By 1931, as the effects of the Hawley-Smoot Tariff ravished the country, attendance sank to only 100,000, with just 665 participants. The year 1932 saw similar numbers arriving in Asbury Park. With unemployment at 22.9 percent and the stock market at just 93, a 73 percent drop from 1929, maintaining the parade—which cost $37,000—for the 1933 summer season proved impossible. The parade, held every year for the past forty years, was canceled for lack of funds.

With the loss of tourism, the North Jersey Shore found itself on the verge of collapse. But tourism was not the only sector to face the disparages of the Depression. The collapse of the North Jersey Shore's economy was three-fold. As tourism fell, so, too, did the banks, followed by housing. Trouble for the local banking industry began with the Seacoast Trust Company of Asbury Park. The largest bank in the area, it provided loans to the numerous

smaller banks in the area. On Tuesday, December 22, 1931, the bank shut its doors without warning, leaving those with accounts at a complete loss and sending fear through investors of Asbury Park's two other banks. By Christmas Eve, fear had turned to panic. Hordes of depositors filled the streets and flowed into both the Asbury Park and Ocean Grove Bank and the Ocean Grove Bank all the way to the teller's window demanding their money. Concerned that the banks could not pay, causing the city's already suffering economy further damage, Mayor Hetrick, who had been severely ill for the last six months, summoned the strength from his bed. Resembling a scene from Frank Capra's *It's a Wonderful Life*, he pleaded with the people to leave their money in the bank and return home. With an ashen face and laboring to speak, Mayor Hetrick, standing in the middle of the angry crowd, urged them, "Don't take your money. If we stick together, we will all come out happy. Don't let us bring the house down on our own heads." He paused for a moment trying to catch his breath. "Is it a go?" he asked. The crowd was silent, and then someone cheered and the rest took it up. Mayor Hetrick smiled and began walking to his waiting car. The crowd joined him, happily helping him before returning to their homes. The next day, however, the people were not so joyful. Both Asbury Park banks shut their doors, and throughout the North Jersey Shore, similar scenes played out. In Long Branch, the New Jersey Trust Company and the Citizens Trust Company shut their doors. In Red Bank, the Merchants Trust Company of Red Bank, the Second National Trust Company and the Broad Street Bank shut their doors. For the time being, people would have to go without money.

Money became so scarce that a barter exchange opened on Monmouth Street in Red Bank, where residents traded goods and services. With the banks closed, tourism faltering and unemployment rising, people began searching for any type of relief. Many set their eyes on the Eighteenth Amendment and the potential tax windfall the country would see from its repeal. The editor of the *Red Bank Register*, following the AAPA's model and using the computations by Professor Heligman of Columbia University, the "greatest authority on taxation," argued for repeal. The paper pointed out the federal government would take in $1.5 million from liquor taxes in just one year, providing much relief for those suffering along the North Jersey Shore. Even Samuel Siciliano, addressing the Italian American Republican organization of Monmouth County, discussed repealing the Eighteenth Amendment as a measure to improve the economy.

Leading up to the Depression, the AAPA had unlocked the door. Now with the economy tattered by a poorly constructed policy, it was wide

open. Taxes became the biggest issue. Speaking at the New Jersey State Taxpayers convention in Atlantic City, Assemblyman Theron McCambell of Holmdel urged all New Jerseyans to go on strike from paying taxes. In his speech titled "My Tax Strike Appeal to the People of New Jersey," he pointed out that the railroads had already gone on strike and that anyone who owned a farm, home, store or factory should do the same. "New Jersey is cursed with the wickedest system of class taxation," he told the convention. He was not too far off. From 1914 to 1929, the state's tax burden more than doubled. The successes of schooling, paved roads and better police techniques all came at a cost. The federal government spent little more than on debt accrued from the First World War and outfitting a modest army of 139,000 men and 96,000 sailors. Calvin Coolidge spoke with little exaggeration when he said, "If the federal government should go out of existence, the common run of the people will not detect the difference in the affairs of their daily life for some length of time." As a result, the indebtedness of the state and tax levy rose considerably, much faster than the average personal income. When the Depression hit, many began demanding balanced budgets. Still others wanted a complete overhaul of the tax system. The heavy property taxes seemed unjust, especially when people began losing their homes.

The North Jersey Shore, home to so many vacation homes, suffered tremendously. Advertisements for sheriff sales filled the local newspapers. In January 1933, the sheriff held ninety-four auctions across the county. From January to March 1933, the sheriff oversaw sixty-three auctions in Red Bank alone. The sheriff's office spent so much time dealing with the massive influx of auctions that the county, struggling with a diminishing tax base, had to allocate a 12 percent increase to the sheriff's budget, and this still was not enough to cover expenses. The crisis of what had now become the Great Depression had hit home. Assemblyman McCambell, comparing the tax collector to a gangster running a racket, found many supporters who had just lost their homes or were very close to doing so. The people of Red Bank found some relief on March 30, 1933 when, at 9:00 a.m., the Merchants Trust Company reopened. For a week leading up to its reopening, flags and signs hung from businesses and homes throughout the town. That day's headlines read "Bank to Open, Town Gay." A holiday spirit was felt throughout Red Bank, but still the town's two other banks remained closed. The small gesture of improvement did not overshadow the woes still facing the thousands living along the North Jersey Shore. Several measures for tax relief were considered by the state legislature,

including consolidation of municipalities, creation of a 2 percent sales tax and income tax, asking state workers to give up a portion of their salaries and rooting out corruption among politicians. Voters overwhelmingly disliked the idea of new taxes. However, the establishment of a special five-man board of inquiry, headed by Assemblyman Stanley W. Naughright, to search out corruption passed the house with a vote of fifty-six to zero. On charges instigated by Theron McCambell, the committee turned its inquiry to the North Jersey Shore.

In 1929, Quinn left the county prosecutor's office to serve in the state senate, and Jonas Tumen of Asbury Park became the county's next prosecutor. He brought in a close friend of his, Harry B. Crook, to head the county detectives. During their tenures in office, the two men systematically turned the office into an extortion racket. It was no shock to some that both Tumen and Crook were corrupt; the two men were extorting thousands of dollars from hundreds of people. However, for those unfamiliar with their doings, the *Red Bank Register*, after the Naughright Commission, concluded its investigation and, in an unprecedented move, printed a four-page article detailing the unbelievable tales of fraud and deception.

A state trooper arrested Alexander Lillien along with his driver, Harry Silver, while he was driving home from the Atlantic City conference in his twelve-ton armored car for carrying a .38-caliber pistol in Spring Lake. While the grand jury returned an indictment against Lillien, Tumen never brought the case to court. Another Lillien associate, Thomas Calandriello, was arrested and indicted by the grand jury for breaking into the American Railway Express Company in Red Bank and stealing a number of packages, yet Tumen, once again, never brought the case to court. A photograph revealed two years after the arrest that Crook was a guest at Calandriello's wedding. When asked to explain his failure to act on the indictments, Tumen stated that he had never heard of either case. When asked why he did not keep the records, Tumen responded, "I had no reason to keep them."

"Then what about the second copy of the records stored in Red Bank by Leo F. Meade?" asked Josiah Stryker, attorney for the Naughright Commission.

"Those have also been destroyed," Tumen told the committee.

"If Mr. Meade and the prosecutor wanted to conceal the use of information the best way would have been to destroy them?" Stryker asked.

"No," answer Tumen.

"Can you suggest a more effective way?" Stryker asked.

Tumen had no comment.

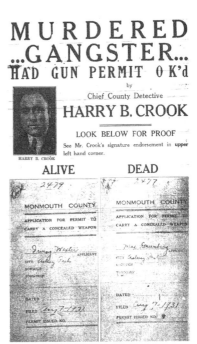

Advertisements by the Monmouth County League for Better Government. *Long Branch Daily Record*, July 1933.

The committee then turned to Harry Crook. Even before Tumen's irregularities were made public, Crook found himself facing accusations made by Richard De Witt, the publisher of the *Long Branch Daily Record*. De Witt claimed that Crook threatened to "rub him out" during a telephone conversation the two men had discussing the *Long Branch Daily Record's* printing of ads by a newly formed group, the Monmouth County League for Better Government. The league began a campaign against public officials they knew were corrupt and used large denunciatory advertisements, many of which aimed at Tumen and Crook, to inform local readers of their actions. The matter made its way into a courtroom where, on the stand, Crook did not deny that the conversation took place but insisted he had made no threats against De Witt. Rather, he just wanted to inform him that he was publishing false ads by a group that had not formally filed the proper paperwork. Since no record of the conversation was made and no witnesses were able to testify that they heard Crook threaten De Witt, all charges were dropped. De Witt and the North Jersey Shore would not have to wait long for Crook to get what he had coming, and this time there was clear evidence to support the charges.

Serving as chief county detective, Crook's position put him in charge of approving gun permits. In their investigation, the state committee found that Abner "Longy" Zwillman, Waxey Gordon, Max Hassel and Max Greenberg all held permits endorsed with the signature, "O.K. H.B Crook." There was clear evidence that Prosecutor Tumen and County Detective Crook were working with the area's most notorious gangsters, but as the committee dug deeper, pressing witnesses harder, it uncovered something much more serious. The two men had established their own racket. Twenty-five witnesses testified that the two men were running their own extortion racket out of the prosecutor's office.

Using Philip L. Phillips, owner of a small men's clothing store in Asbury Park, as the bagman, both Crook and Tumen extorted money from owners of speakeasies. Phillips spent his days traveling to locations known to be selling alcohol, collecting payments and establishing yearly payments to be made to him at his clothing store. Walter Keener told the committee that when he went to pay off Phillips in 1932, a dozen or so owners stood around waiting to pay their dues. Tumen, through Phillips, collected from $250 to upward of $1,000 a year from scores of liquor sellers. Not satisfied by just taking from known sellers, Tumen sent Crook out to find more illegal operations and put them on his protection payment plan. It was a lucrative scheme that was making all three men very wealthy. To find out just how much money the men were making, the committee attempted to examine each man's bank records. They only found Crook's. Not wise enough to hide the money during the same period when many around him were losing their homes and jobs, the committee found he had made $16,035 from 1930 to 1933. After the lengthy investigation, the committee had more than enough evidence to remove both men from their positions. Neither actually went to jail. Tumen was removed from office by the Supreme Court and replaced by Edward W. Currie of Matawan, whose first action in office was to remove Harry Crook from his position as chief detective.

Tumen and Crook were by far the most glaring examples of corruption the state dealt with, but on the local level, those who cooperated with gangsters found themselves fixed sharply in the cross hairs of an angry and financially desperate population. Thanks in large part to the efforts of the League for Better Government, Samuel B. Zartman, police commissioner of Long Branch, lost his job after accusations that he was taking a weekly bribe of seventy-five dollars from gangsters operating a gambling racket in the city proved true, allowing Cornelia Wooley to become Long Branch's first female police commissioner.

Former police chief of Atlantic Highlands John Snedeker, now serving as mayor, came under fire for his unscrupulous ways. Instead of accusations coming from the League for Better Government, Snedeker found himself facing charges instigated by a former friend and rumrunner. Andy Richards, like many rumrunners, invested his profits in local businesses. Richards opened Richards' Beach, located just adjacent to the Atlantic Highlands Amusement Park. His chief competitor was Kilcullen Beach. Luckily for Richards, Kilcullen Beach burned down in the summer of 1933, and its owner, Patrick Kilcullen, unable to pay his taxes, lost his property to the town. Richards, suffering from the loss of tourism during the Depression, jumped at the opportunity to begin charging beachgoers a small fee to use his beach in an attempt to recover some of the lost revenue from tourists foregoing the snack bars in favor of bringing their own food. However, Mayor Snedeker, with the town in control of Kilcullen Beach, decided to open the beach to the public free of charge and at the expense of $14,000 to taxpayers. In 1933, when Snedeker ran again for mayor, Richards attacked him for not using the beach as a source of revenue for the township. Spending his own money to purchase ad space in newspapers, Richards openly attacked his former business partner, telling a reporter from the *Long Branch Daily Record* that Snedeker was using taxpayer money to fight his own battles and reminding readers of Snedeker's alleged misuse of a police motorcycle or the time when a truckload of confiscated bottles of champagne suspiciously disappeared and reputedly ended up at Snedeker's home. Oddly, Richards never mentioned the bribes he paid to Snedeker.

After the fire at Kilcullen Beach, Snedeker ordered the town workers to remove the debris and prepare it to open again. Controversy arose over the removal of the damaged carousel from the beach. Kilcullen claimed that Snedeker stole it and sold it to a junkman, and Richards reasserted the theory in every paper that would print the story. So much was made of the story that charges were eventually filed, and Snedeker was arrested for larceny. Whether Snedeker should have been arrested for cleaning up the beach is arguable; however, it shows that people were finished, at least for now, with irresponsible politicians.

Blaming the country's problems on the misgivings of foreigners would not stand. As in the films and women's clothing, logic and formality would guide a record number of voters in the election of 1932. In 1924, 1,088,054 New Jersey voters overwhelmingly supported the Republican Party. In 1932, 1,630,063 came out to cast their vote in the presidential election in New Jersey, with 806,630 choosing Franklin Delano Roosevelt.

It was the first time since 1912 that the voters in New Jersey chose a Democrat for president. In Monmouth County, the voters primarily chose Republican candidates, yet this year candidates forwent fear mongering in favor of presenting themselves as "Courteous and Efficient" and "producing profits instead of deficits," as the Republican candidate for county surrogate, Joseph Donahay, did in his successful bid for reelection. Most importantly, incumbents attempting to win reelection distanced themselves as far as they could from any corrupt politicians. Donahay reminded voters that the surrogate's office remained controversy free. In Highlands, Mayor Hardy failed to convince voters that he did not work with gangsters and lost his bid for reelection to Frank Bedle. Perhaps the most important factor guiding voters in the election was the question of Prohibition. Maintaining the current system, with its propensity to corrupt politicians, seemed a senseless choice. Overwhelmingly, the voters of New Jersey chose wet candidates to represent them.

During the election of 1932, Roosevelt campaigned for repeal. Even Hoover admitted that Prohibition caused more crime than it was designed to prevent. After the election of 1932, the end was in sight. Gordon and his partners, Max Hassel and Max Greenberg, planned to turn their underground breweries into legitimate operations as soon as the Twenty-first Amendment went into effect. Now, as repeal came closer, the federal government established licenses for breweries and distilleries. Gordon, Hassel and Greenberg each filed for one. Reinfeld did the same but as an importer, establishing the company Browne Vinters, importing Remy Martin, Piper-Heidsieck, Cointreau and White Horse. Luciano, if he could not reap the profits of bootlegging, planned to extort legitimate liquor businesses after repeal. The Commission informed all future licensed brewers and distillers that they would pay a duty to the gang or face bombings, arson and truck hijackings. To prove they would enforce their measure, the Commission planned to hire 2,500 "checkers" to ensure their will was enforced. Gordon, Hassel and Greenberg refused to pay. For Luciano, that meant Gordon's gang would have to go. However, before Gordon or those in his gang learned of their fates, the underworld was shaken up after one of the largest gangsters met an untimely end.

In March, Lillien was killed. Whether Luciano and his friend Lansky did it remains a mystery. Many theories abound over his murder. It was known that Lillien and his men frequently ran into conflict with Charles "Vannie" Higgins, the bootleg boss of Brooklyn and Long Island and an associate of Luciano. Maybe Lillien planned to make his operation legitimate, as Reinfeld was planning, and refused to pay Luciano. However, all signs point to Luciano.

On a cold March day, two members of Lillien's gang found him dead on the top floor of the Mansion with three bullet wounds to the back of the head and neck. Lying next to his body was a pair of pallbearer gloves and an upturned king of spades. He was thirty-six at the time of his death.

In April, Luciano struck against Gordon, Hassel and Greenberg. In Elizabeth, New Jersey, at the Elizabeth-Carteret Hotel, the three men rented a three-bedroom suite at the hotel for $150 a week to use as an office for their bootleg business. The events that transpired in the room on the afternoon of April 12 are sketchy at best. At the end of the day, both Hassel and Greenberg were killed, leaving only Gordon to tell the story. Fearing for his life, he managed to forget most of the details. However, all signs point to Lansky working for Luciano behind the assassination attempt. Lansky had no problem killing Gordon. The two men had hated each other ever since Lansky had hijacked four trucks destined for Gordon in 1927. This is the story, as Gordon and newspaper reporters covering the story told it.

After returning from a golf outing, the three men and several others returned to the hotel, where they drank and discussed business. Shortly into their discussion, one of the unknown men handed Greenberg a check for $2,500. He took it and walked into an office just adjacent to the living room, intending to put it in a safe place. Three of the men causally accompanied him, making small talk as they walked into the room, shutting the door behind them. At some point during the transaction, Gordon got up from his chair in the living room and, for undetermined reasons, walked into one of the bedrooms, leaving Hassel alone in the living room with two others. Suddenly, shots rang out from the office. Greenberg was struck five times in the head and chest, dying immediately. Hassel, hearing the shots, jumped out of his chair and ran for the office door. He was shot three times from behind and died before he hit the ground. Gordon managed to stay hidden during the attack and snuck out a side door. Fearing for his life, he fled to upstate New York, where he could manage his business far removed from the danger on the North Jersey Shore.

The danger was very real. Bodies continued to pop up along the North Jersey Shore. In September 1931, Patrick Finn and Philip Ascher from the Lower East Side were vacationing on the North Jersey Shore when they were found beaten to death in a bungalow on Dakota Avenue in East Keansburg. In typical gangland fashion, the men never saw it coming. When authorities uncovered their bodies, a pot of coffee was boiling and an empty bottle of liquor lay on the floor. In December 1931, a member of Lillien's rumrunning syndicate, Jimmy Granato of Keyport, was found dead in a shallow grave in Breille. He had been strangled and shot twice in the head, and then his body

The Mansion, location of Alexander Lillien's murder. *Asbury Park Evening Press*, March 24, 1933.

was covered in acid and thrown into the grave. In August 1932, another body turned up, this time in the marshes of Monmouth Beach. The body of Tony Boccio from Brooklyn was found sewn in a sack, leading police to believe he was killed somewhere else and dumped in Monmouth Beach. In July 1933, another body appeared, this time in the small stretch of woods between the Shark River Golf Course and Corlies Avenue in West Neptune. The man, who was never identified, had his hands bound behind his back and his legs tied and drawn into his chest. He was shot twice in the chest and dumped into the shallow grave on the edge of the golf course.

Luciano, as wise in business as he was in underworld dealings, attempted to put Gordon's gang out of business when the easy approach of killing his competition did not work. He turned to an associate of his, Dutch Schultz, and asked him to distribute his beer on the North Jersey Shore. Just as the summer season of 1933 began, Gordon's usual customers slowly were disappearing. His customers had been complaining that the beer he was selling was becoming weaker and weaker, but with no alternative, they kept buying. However, now that Schultz had come down from the Bronx in New York City and established

himself in Long Branch, selling beer that had not been mixed with anything, they eagerly bought from him instead of Gordon. It did not take Gordon long to figure out what had happened. He sent three of his men to a warehouse at 66 Fourth Avenue in Long Branch, where Joe Pingitore ran a wholesale beer distribution operation. At 8:30 a.m. on July 5, 1933, the men snuck through the side entrance, surprising those inside. Quickly, Gordon's men tied up those inside and threatened Pingitore and his workers to stop buying from Schultz. The message was sent: Gordon controlled the North Jersey Shore. But the message was also sent to Luciano: Gordon was not going down without a fight.

When killing him or putting him out of business did not work, Luciano decided to use the government. Waxey Gordon never liked paying taxes, and unlike members of the AAPA, he simply did not. Actually, in 1930, he owed the federal government $1,427,531.00, of which he paid a mere $10.76. Waxey lived a lavish lifestyle. His child could be seen riding his horse through Central Park with Gordon looking on wearing suits costing $225.00 from Al Capone's tailor with $10.00 socks and $45.00 silk briefs. He maintained two homes for his family: one in New York City, costing $6,000 a year in rent, and another in Bradley Beach. Even still, Gordon claimed he earned only $8,125.00 a year. Luciano somehow managed to obtain documents proving that Gordon had never paid taxes and ordered Jake Lansky, Meyer Lansky's brother, to deliver information about Gordon's finances to Thomas Dewey, assistant attorney for New York. With the information provided by Luciano, it did not take long for the government to make a case of tax evasion against Gordon. Federal agents arrested him, and he stood trial in December 1933. He faced a rising star in the district attorney's office, Thomas Dewey.

Unlike Lillien and his codefendants, Gordon decided to take the stand and explain away the charges. This was a poor move when facing Dewey. Just thirty-one, he would be an adversary who well outmatched Gordon. Gently questioned by his white-haired, fatherly looking attorney, Gordon painted himself as a misguided individual. For his entire forty-seven years, he had managed to get himself caught up with the wrong people. He pleaded, "I was only a cog in the [bootleg] machine." He went on to explain, while licking his lips, constantly shifting position and violently rubbing his thumbs, that he had only done it for his family. All he made was $150 a week; this increased to $175, which he reported on his taxes. His lawyer pressed him: "But that does not add up to your claimed $8,125." Gordon responded that he was simply "generous in such matters" and pointed to the "usual" donations of $100 to the Riverside Synagogue and $25 to the United Jewish Charities he made, despite his meager salary. Next came the

cross-examination by Dewey, and he was not as gentle as Gordon's attorney. The prosecution had estimated Gordon made $1,338,000 in 1930 and $1,026,000 in 1931. Instead of attacking Gordon's financial discrepancies outright, he threw him off with an unrelated question that forced Gordon to admit he made much more than $8,000. Dewey began by stating, "You obtained three pistol permits from Asbury Park." He read from Gordon's own permit: "Reason for carrying application—Carried large sums of money on person for business purposes."

"Is that right?" Dewey asked Gordon.

"At times, yes," Gordon responded.

"I suppose the money wasn't yours?" Dewey quickly quipped.

"It was not," Gordon answered.

Gordon stared at the ceiling, his back hard against his chair. He refused to make eye contact with Dewey. Dewey played it perfectly. After many questions, Dewey forced Gordon to recant his responses to his gun permits. He finally admitted that he was a bootlegger but still insisted that he was not the ringleader. Instead, the leaders were Max Hassel and Max Greenberg, and since their death, the gang had broken up. "If the other members of the gang were here, would they corroborate your testimony?" Dewey asked Gordon. Before he could answer, his attorney objected. "This line of cross examination is malicious" and "intended to prejudice the jury," he called out. The judge agreed, and Dewey returned to questioning Gordon's lavish lifestyle. Gordon and his wife went to Europe twice in 1932, lived in a $6,000-a-month apartment, owned $100,000 worth of antiques and insured everything heavily. "I owe $80,000 in debt," Gordon told the courtroom. Trying to figure out where Gordon found the money to pay his debts Dewey asked, "How did you make your living after 1916?"

"For several years I was in the real estate business…as a broker."

"Real estate and whiskey?" Dewey asked with a serious sternness only the most determined man could show. "Isn't it true you never sold a piece of real estate in your life?"

"That isn't so," Gordon quickly retorted.

Dewey continued hammering Gordon about his real estate business until finally he broke.

"When did you stop being a real estate broker?" Dewey pressed.

"I wasn't at it long."

As Gordon provided no other occupation, Dewey jumped at his chance. "In fact you were in the whiskey business, isn't that so?"

Gordon's face sunk, and he slumped down in his chair. "That is right," he sheepishly admitted.

On that, Dewey rested his case. The next day, the jury would decide Gordon's fate. It was not a hard decision for the jury to make. With Gordon unable to provide any legitimate reason for carrying a weapon or a legitimate occupation that enabled him to enjoy a luxurious life during a time when most of the country was suffering economically, in forty-five minutes they returned and found him guilty. The judge ordered him to forfeit all of his property and pay an $80,000 fine and sentenced him to ten years in prison. Gordon was shocked and almost fainted. So was the end of Gordon's bootlegging days.

With Lillien dead and Gordon on his way to jail, the days of rumrunning along the North Jersey Shore were numbered. So were the days of Prohibition. Less than a week after a jury found Gordon guilty, Prohibition came to an end on December 6, 1933, at 5:20 p.m. Exactly thirteen years, ten months and nineteen days after the passage of the Eighteenth Amendment the Twenty-first Amendment went into law. Prohibition was over.

BIBLIOGRAPHY

Primary Sources

Newspapers

Asbury Park Evening Press. "Advertisement," May 21, 1923.
———. "Fear Keyport Girl Is Slavers' Victim," September 6, 1913.
———. "Missing Keyport Girl Is Found by Brother in N.Y.," September 11, 1913.
———. "Robbed He Says on Slumming Trip," October 7, 1913.
———. "Spurious Liquor Permits in State," June 3, 1920.
Asbury Park Morning Press. "Bradley Ban on One Piece Garb," July 5, 1915.
Bluefield Daily Telegraph. "Oddities in the News," August 22, 1926.
Echo. "Advertisement," April 4, 1925.
———. "Citizens Accorded Privileges at Keansburg," August 23, 1924.
———. "White Press and Klan Seeks to Kill Beach," August 1, 1925.
Keyport Enterprise. "Autoists Pay Fines," June 4, 1924.
———. "Keyport Man Shot by Gang of Hi-Jackers," July 18, 1924.
Keyport Weekly. "Automobile Was Stolen on Carr Ave," June 4, 1924.
———. "Big Klan Gathering at Elkwood Park," July 11, 1924.
———. "In Justice Currie's Court," September 5, 1924.
———. "Keansburg Man Killed by Auto," August 15, 1927.
———. "Klan Gives Purse as Sympathy Token," July 18, 1924.
———. "Matawan Druggist Kidnapped and Robbed," July 18, 1924.
———. "Newarkers Out-Wit Hold up Men and Save Cash," August 1, 1924.
———. "Recovered His Automobile," June 4, 1924.
———. "Rum Battle at Keansburg," August 15, 1924.
———. "Six Jersey City Men Held After Mishap," July 19, 1928.
———. "Three Men Identified as Hijackers," August 1, 1924.

Long Branch Daily Record. "Advertisement," August 6, 1926.
————. "Advertisement," July 3, 1926.
————. "Alledged Rum Ring Members Are Freed," July 13, 1931.
————. "Are Found Guilty of Illegal Sales," July 23, 1921.
————. "Asks That Evidence Be Submitted," August 13, 1921.
————. "At the Theatre," August 6, 1926.
————. "Auto Travel Breaks Record," July 10, 1922.
————. "Bugbee Admits Defeat," November 5, 1919.
————. "Call Dry Law Act of Cowards," September 15, 1919.
————. "Capone, Hobart Bank Linked by Authorities with Rum Syndicate," October 19, 1929.
————. "Coronation Ball," August 27, 1926.
————. "Deal Inn Raided by Federal Men," June 14, 1926.
————. "Declare Liquor Trade Picking up Briskly," May 16, 1923.
————. "Dry Agents Raid Needling Plant," July 12, 1927.
————. "Enforcement of Prohibition Will Be Discouraged Under Democratic Administration," November 7, 1919.
————. "Fined for Driving with Only One Arm," July 1, 1924.
————. "Five Union Beach Stores Are Raided," July 10, 1925.
————. "Graft Conditions Exposed," June 2, 1926.
————. "Hidden Radio Station Located Near Armed Base," October 19, 1929.
————. "Highlands Is Completley Surprised by Big Raid," October 19, 1929.
————. "Klan Meeting Last Night Ends in Riot," Septmeber 1, 1923.
————. "Liqour League Will Try to Prevent Dry Enforcement," September 26, 1919.
————. "Local Police and County Detectives Have Busy Evening," August 11, 1925.
————. "Local Police Seize 49 Cases, 11 Bottles of El Bart Gin from Packard Truck," July 9, 1921.
————. "Ocean Grove Yields Large Quantity of Assorted Beverages," July 15, 1927.
————. "One Dead Six Wounded as Result of Pistol Fight at Atlantic Highlands," October 23, 1923.
————. "Red Banker Heard in Rum Ring Trail," July 9, 1931.
————. "Rum Case Jurors Told of Transfer of Bank Account," July 3, 1931.
————. "Rum Ring Paid $30,000 Week for Protection, Book Shows," October 18, 1929.
————. "Silver Slipper Is Found Again Visited," August 2, 1926.
————. "Silver Slipper Is Found All Wet," July 12, 1926.
————. "Women Aid Men in First Public Klan Initiation," June 4, 1923.
Newark Evening News. "Felis Pardus Bites the Dust," October 20, 1926.
New York Times. "Abolish State Lines for New Dry Way," June 25, 1925.
————. "Affidavit Backs Asbury Charges," April 4, 1924.
————. "Aged Persons Swindled," December 25, 1927.

———. "Anderson Attacks Catholic Church," March 6, 1920.

———. "Andrews Realigns Prohibition Forces," November 10, 1926.

———. "Anti Klan Speaker Rescued by Police," June 18, 1925.

———. "Anti-Saloon League Threaten to Impeach Judges," September 16, 1920.

———. "Asbury Park and Its Founder," August 11, 1912.

———. "Auto Kills Boy on Bicycle," June 21, 1921.

———. "Auto Leaps Curb Six Children Hurt: Four Persons Are Killed in New Jersey in Weekend," August 12, 1924.

———. "Bank to Open Town Gay," March 30, 1933.

———. "Black Hand Threat to Founder Bradley," August 9, 1911.

———. "Bombs Made by Terrorists," April 4, 1912.

———. "Bootleggers Raise Prices," August 16, 1924.

———. "Brass Buttons and Blue Garb," October 9, 1926.

———. "Brewery with Capacity of 100 Barrels a Day Seized in Centre of Jersey Town," August 7, 1920.

———. "Bugbee Answers Drys," October 14, 1919.

———. "Bugbee Arraigns Wets," October 27, 1919.

———. "Bullets Fly in War with Rum Pirates," March 23, 1923.

———. "Buncoed for $10,000 Trying to Buy Rum," August 22, 1921.

———. "Cash Gone After Dry Raid," August 26, 1922.

———. "Drinkers Barred as Dry Enforcers," September 23, 1926.

———. "Dry Agent the Only One Arrested," August 27, 1922.

———. "Dry Issue to Fore in New Jersey Election," November 4, 1919.

———. "Dry Law Violators Here Mostly Foreigners," June 12, 1923.

———. "Dry Raids at Keansburg," November 27, 1930.

———. "Edwards Wins New Jersey," November 5, 1919.

———. "11 Coast Guard Men Now Under Arrest," July 23, 1926.

———. "Ex-Chaplain Arms to Repel Klansmen," February 1, 1925.

———. "15,000,000," September 28, 1930.

———. "Fifty Are Indicted as Huge Liquor Ring," April 18, 1930.

———. "Four Men Arrested as Jersey Liquor Ring." August 2, 1929.

———. "14 Raids Stir Asbury Park," August 25, 1922.

———. "Gale Hits Rum Row and Dry Besiegers: Informers to Get Reward," May 7, 1925.

———. "Girl Dies in Stunt Boarding Airplane from Running Auto," October 21, 1921.

———. "Gordon Says He Got $300 a Week," December 1, 1933.

———. "Held as White Slaver," September 11, 1913.

———. "Holds Wire Tapping Gives Hearsay Only," April 22, 1931.

———. "Huge Crowds Jam All Shore Resorts as Holiday Begins," July 4, 1927.

———. "Hunt Jersey Woods for Roving Leopard," August 7, 1926.

———. "Indian Leopard Escapes Middletown Zoo," August 6, 1926.

———. "Inside Story of Prohibition's Adoption," March 29, 1926.

———. "Instant Prohibition Plea to President," March 10, 1918.

———. "Italian Outlook," January 27, 1925.

———. "Jersey Bar Urges Dry Law Repeal," February 9, 1930.

———. "Jersey Leopard Enjoys Quite Day," August 10, 1926.

———. "Jury Aquits 17 in Rum Ring Trail," July 12, 1931.

———. "Klan Plans Radio Station," February 26, 1925.

———. "The Klan's Invisible Empire Is Fading," February 21, 1926.

———. "Klansman Unmasks to Speak at Church," June 4, 1924.

———. "Klansmen Honor American Mothers," May 11, 1925.

———. "Knocks Off Hoods, Beats 3 Klansmen," June 25, 1923.

———. "Ku Klux Klan Now Has 50 Klans in New Jersey," August 30, 1921.

———. "Lays Crime Wave to Church Rows," May 14, 1928.

———. "Link Gun Battle to Bootlegging Trade," October 22, 1923.

———. "Links Drafts to Rum Ring," July 9, 1931.

———. "Liquor Stolen from Police," October 15, 1925.

———. "Map of Lower East Side," April 3, 1910.

———. "Ministers Attack Wets," September 22, 1924.

———. "Modern Womenhood Sadly Shirks Holy Duty," July 12, 1914.

———. "Move to Close Deal Inn," August 6, 1924.

———. "Nation Voted Dry," January 17, 1919.

———. "New Jersey Files Anti Dry Suit," March 5, 1920.

———. "New Jersey Klan's Women in Outdoor Initiation," August 19, 1923.

———. "New Jersey Klan Threat Stirs Bootleggers." January 15, 1924.

———. "New Summer Resort," July 23, 1881.

———. "Omit Prohibition Jubilee," March 18, 1919.

———. "181,000 Union Men to Strike if Beer Is Outlawed," February 22, 1919.

———. "130 Dry Raiders Sweep Along Coast; Get Arsenal and Rum Ring's Wireless," October 17, 1929.

———. "Open Fight on Edwards," December 13, 1919.

———. "Perth Amboy Shacky After Rout of Klan," September 1, 1923.

———. "Plan State Fight for Local Option," January 12, 1914.

———. "The Polluted Beaches," July 24, 1923.

———. "Polluted City Beaches a Danger to Bathers," July 17, 1927.

———. "Predicts Prohibition Soon," March 9, 1918.

———. "The Prohibition Amendment," February 17, 1917.

———. "Puts Ban on Crime News," June 7, 1927.

———. "Racket Chief Slain," April 16, 1931.

———. "Rail Road Earnings," February 7, 1931.

———. "Ratifies Prohibition Amendment," January 10, 1918.

———. "Ratifies Prohibition in Fifteen Minutes," January 9, 1918.

———. "Reverses Order of Flags," May 13, 1913.

———. "Robed Riders Lead Public Klan Parade," June 3, 1923.

———. "Routes Outlined to Polo Game," August 26, 1922.

———. "Rum Radio Ring Head Slain in New Jersey," March 24, 1933.

———. "Rum Ring Got Hint of Raids in Advance," October 21, 1929.

———. "Rum Ring Paid Big Bribes, Seized Records Reveal; 6 Months Profit $2,000,000," October 18, 1929.

———. "Say Liquor Ring Put $1,000,000 in Banks," April 16, 1930.

———. "Says Drys Plan Religous Schism," March 11, 1920.

———. "Slump Threatens Parade of Babies," June 18, 1933.

———. "Spade King Clue in Lillien Slaying," March 25, 1933.

———. "Tax of 882,000,000 Laid to Prohibition," March 16, 1931.

———. "Tells Why Dry Laws Are Not Enforced," June 29, 1921.

———. "35,000 Hear Jersey Speech," August 23, 1924.

———. "Three More Banks Closed in New Jersey," December 25, 1931.

———. "3 Policemen Held for Auto Killing," September 15, 1929.

———. "To Ask for a Padlock on Entire Ritz," July 15, 1924.

———. "To Crusade on Autos with Offensive Signs." June 30, 1926.

———. "To War on Rum Runners," March 25, 1926.

———. "Town Seething in Liquor," January 12, 1923.

———. "Two Rum Ships Hit with Solid Shot," June 10, 1923.

———. "Two Slain in Hotel in Jersey Rum War," April 13, 1933.

———. "Unpaid Chauffer Shot Ex-Dry Agent," Septmeber 11, 1922.

———. "Vendetta Suspected in Booleggers Killing," January 27, 1923.

———. "Wait Says Conger," January 22, 1910.

———. "Wants Oil Plague Abated," August 23, 1920.

———. "Wants Rum Fleet Seized," March 10, 1923.

———. "Wets Lead in Poll by Literary Digest," March 14, 1930.

———. "Would Oust Klan Leaders," September 21, 1921.

Red Bank Register. "Advertisement," April 22, 1914.

———. "Advertisement," August 8, 1924.

———. "Anti Ku Kluxers," August 22, 1923.

———. "Asbury Park Liquor Raid," September 13, 1922.

———. "Atlantic Highlands News," May 28, 1924.

———. "Aviators Cheat Death," May 28, 1924.

———. "Big Attendance at Zoo," October 20, 1926.

———. "Big Event for Aviators," July 10, 1929.

———. "A Big Sign," August 21, 1929.

———. "Booze in Wrecked Auto," December 22, 1920.

———. "A Burning Cross," August 22, 1923.

———. "Catnip for Leopard," September 8, 1926.

———. "Colts Neck News," September 1, 1926.

———. "County Probe Comes to an End," December 20, 1934.

———. "A Dog's Sad Fate," September 8, 1926.

———. "Fair Haven News," April 5, 1916.

———. "A Federal Indictment," November 6, 1929.

———. "Feminine Sign Painter," July 26, 1922.

———. "A Fiery Election Cross," Novemeber 11, 1925.

———. "Fourth of July Parade," July 10, 1929.

———. "Grapes and Rhubarb," July 21, 1926.

———. "Hand Blown Off by Bomb," April 3, 1912.

———. "He Carried No Liqour," July 17, 1929.

———. "Home Sweet Home Brew," November 21, 1928.

———. "Hot Scrap for Office," May 27, 1925.

———. "The Humble Dandelion," May 21, 1924.

———. "Italian Club Meeting," May 13, 1933.

———. "John Quinn Sworn In," April 15, 1925.

———. "Juice Grape and Their Uses," September 7, 1927.

———. "Keansburg Rum Confiscated," September 22, 1922.

———. "Kidnapped Girl Is Home," December 14, 1910.

———. "Killed by Automobile," June 22, 1921.

———. "Klan Celebrates," June 4, 1924.

———. "Klan Invited to Church," July 1, 1925.

———. "Klansmen at Red Hill," March 25, 1925.

———. "Leopard at New Monmouth," September 22, 1926.

———. "Leopard Killed at Last," October 20, 1926.

———. "Lincroft News," August 18, 1926.

———. "Monmouth County Budget," February 15, 1933.

———. "Murder at Asbury Park," September 30, 1925.

———. "Murder in Fair Haven," September 13, 1922.

———. "Nearly $20,000 in Fines," December 22, 1920.

———. "New Auto Cops at Work," August 6, 1924.

———. "New from Middletown," September 29, 1926.

———. "News from Middletown," August 27, 1924.

———. "News from Middletown," March 25, 1925.

———. "Ninety Four Sheriff Sales in January," February 15, 1933.

———. "1,500,000,000 Thrown Away," July 13, 1932.

———. "Our Popular Firemen," March 4, 1925.

———. "Police Chief Arrested," Septmeber 22, 1920.

———. "Raids at Asbury Park," August 19, 1925.

———. "Reclaiming Low Land," August 30, 1922.

———. "Red Bank's Speed King," July 10, 1929.

———. "Rumson News," August 26, 1922.

———. "Sale of Elkwood Park," July 2, 1924.

———. "Sermon About Socialism," February 19, 1913.

———. "Sheriff Sale," January–March 1933.

———. "Shooting on the Street," August 22, 1923.

———. "Sixteen Cases of Liquor Stolen from City Hall," June 18, 1924.

———. "Stolen and Found," June 23, 1926.

———. "Taxpayers Urged to Strike," June 15, 1932.

———. "Temperance Banquet," June 2, 1920.

———. "Terrorism in Red Bank," March 23, 1910.

———. "Thief Scared Away," August 25, 1926.

———. "Town Talk," August 22, 1923.

———. "Town Talk," July 8, 1925.

———. "Town Talk," May 28, 1924.

———. "Trouble for Clammers," August 23, 1923.

———. "Trouble over the Police," August 27, 1924.
———. "Visit Atlantic Highlands," August 27, 1924.
———. "Won Leopard's Hunt," September 15, 1926.

Magazines, Reports, Websites, Interviews

Association Against the Prohibition Amendment. *Scandals of Prohibition Enforcement.* Ann Arbor, MI: The University of Michigan Press, 1929.
Dosch, Arno. "Just Wops." *Everybody's Magazine*, November 1911.
Jane Halleran, interview by author, November 24, 2009, Port Monmouth, NJ.
Harbors, United States. Congress. House. Committee on Rivers and. *Pollution of Navigable Waters: Hearings on the Subject of the Pollution of Navigable Waters Held before the Committee on Rivers and Harbors, House of Representatives, Sixty-seventh Congress. October 25, 1921, Volumes 1–2.* Washington, D.C.: Goverment Printing Office, 1921.
Literary Digest. "Coolidge and Common Sense," August 1924.
Wine Facts, Statistics and Trivia. www.napanow.com/wine.statistics.html.

SECONDARY SOURCES

Abott, Karen. *Sin in the Second City: Madams, Ministers, Playboys and the Battle for America's Soul.* New York: Random House, 2007.
Allaback, Sarah. *Resorts & Recreation an Historic Theme Study of the New Jersey Coastal Heritage Trail Route.* Mauricetown, NJ: Sandy Hook Foundation and the National Park Service, 2005.
Allen, Fredrick Lewis. *Only Yesterday: An Informal History of the 1920s.* New York: Perenial Press, 1931.
Anbinder, Tyler. *Five Points: The 19th-Century New York City Neighborhood that Invented Tap Dance, Stole Elections, and Became the World's Most Notorious Slum.* New York: Simon and Schuster, 2001.
Asbury, Herbert. *The Gangs of New York: An Informal History of the Underworld.* New York: Random House, 2008.
———. *The Great Illusion: An Informal History of Prohibition.* Santa Barbara, CA: Greenwood Press, 1968.
Behr, Edward. *Prohibition: Thirteen Years That Changed America.* New York: Arcade Publishing, 1996.
Bennett, David H. *The Party of Fear.* New York: Vintage Books, 1995.
Blee, Kathleen M. *Women of the Klan: Rascism and Gender in the 1920s.* N.p.: University of California Press, 2009.
Block, Lawrence. *Gangsters, Swindlers, Killers, and Thieves: The Lives and Crimes of Fifty American Villians.* New York: Oxford Press, 2004.
Boyd, Paul D. *Atlantic Highlands: From Lenape Camps to Bayside Town.* Portsmouth, NH: Arcadia Publishing, 2004.
Chalmers, David M. *Hooded Americanism: The First Century of the Ku Klux Klan, 1865 to the Present.* Garden City, NY: Doubleday and Company, 1965.

Dash, Mike. *Satan's Circus: Murder, Vice, Police Corruption, and New York's Trial of the Century*. New York: Random House, 2008.

Dorchester, Daniel. *The Liquor Problem in All Ages*. Boston: Harvard University Press, 1888.

Downey, Patrick. *Gangster City: The History of the New York Underworld 1900–1935*. Fort Lee, NJ: Barricade Books, 2009.

Faith, Nicholas. *The Bronfmans: The Rise and Fall of the House of Seagram*. New York: St. Martin Press, 2006.

Fass, Paula S. *The Damned and the Beautiful: American Youth in the 1920s*. New York: Oxford University Press, 1977.

Federal Writers' Project of the Works Progress Administration. *New Jersey: A Guide to Its Past and Present*. New York: Viking Press, 1939.

Fox, Stephen R. *Blood and Power: Organized Crime in Twentieth-Century America*. Ann Arbor: University of Michigan Press, 1989.

Frasca, Dom. *King of Crime*. New York: Crown Publishers, 1959.

Fried, Albert. *The Rise and Fall of the Jewish Gangster*. New York: Columbia University Press, 1993.

Gabrielan, Randall. *Images of America: Atlantic Highlands*. Dover, NH: Arcadia Publishing, 1996.

Gatley, Lian. *Drink: A Cultural History of Alcohol*. New York: Gotham Books, 2008.

Gilfoyle, Timothy J. *City of Eros: New York City, Prostitution, and the Commercialization of Sex, 1790–1920*. New York: W.W. Norton & Company, 1994.

Jefferys-Jones, Rhodri. *The FBI: A History*. Binghamton, NY: Vail-Ballou Press, 2007.

Keefe, Rose. *The Starker: Big Jack Zelig, the Becker-Rosenthal Case, and the Advent of the Jewish Gangster*. Nashville, TN: Cumberland House, 2008.

Kennedy, David M. *Freedom from Fear: The American People in Depression and War, 1929–1945*. New York: Oxford University Press, 1999.

Kessner, Thomas. *The Golden Door: Italian and Jewish Immigrant Mobility in New York City 1880–1915*. New York: Oxford University Press, 1977.

King, John P. *Views of Highlands: A Pleasant Land to See*. Highlands, NJ: King, 1996.

Kobler, John. *Ardent Spirits: The Rise and Fall of Prohibition*. New York: Da Capo Press, 1973.

Konigsberg, Eric. *Blood Relation*. New York: HarperCollins, 2005.

Leach, William. *Land of Desire: Merchants, Power, and the Rise of a New American Culture*. Pantheon Books, 1993.

Lee, Henry. *How Dry We Were: Prohibition Revisited*. New York: Prentice-Hall, 1963.

Link, Arthur S. *Woodrow Wilson and the Progressive Era*. New York: Harper and Row, 1954.

Maclean, Nancy. *Behind the Mask of Chivalry: The Making of the Second Ku Klux Klan*. New York: Oxford University Press, 1994.

Mass, Peter. *The Valachi Papers*. New York: G.P. Putnam's Sons, 1968.

Miller, Nathan. *New World Coming: The 1920s and the Making of Modern America*. New York: Scribner, 2003.

Morone, James A. *Hell Fire Nation: The Politics of Sin in American History*. New Haven, CT: Yale University Press, 2003.

Moss, George, and Karen L. Schnitzspan. *Victorian Summers at the Grand Hotels of Long Branch, New Jersey*. Seabright, NJ: Ploughshare Press, 2000.

Ogle, Maureen. *Ambitious Brew: The Story of American Beer*. Orlando, FL: Harcourt Books, 2006.

Pietrusza, David. *Rothstein: The Life, Times, and Murder of the Criminal Genius Who Fixed the 1919 World Series*. New York: Caroll and Graf Publishing, 2003.

Reppetto, Thomas. *American Mafia: A History of Its Rise to Power*. New York: Henry Holt and Company, 2004.

Riis, Jacob A. *How the Other Half Lives: Studies of the Tenements of New York*. New York: Charles Schribner and Sons, 1914.

Rockaway, Robert A. *But—He Was Good to His Mother: The Lives and Crimes of Jewish Gangsters*. Jerusalem, Israel: Gafen Publishing House, 1993.

Roe, Clifford. *The Great War on White Slavery*. Charlottesville: University of Virginia, Garland Publishing, 1979.

Rose, Kenneth D. *American Women and the Repeal of Prohibition*. New York: New York University Press, 1996.

Schlaes, Amity. *The Forgotten Man*. New York: HarperLuxe, 2007.

Sklar, Robert. *Movie-Made America: A Cultural History of American Movies*. New York: Vintage Books, 1975.

Sloat, Warren. *A Battle for the Soul of New York: Tammany Hall, Police Corruption, Vice, and Reverend Charles Parkhurst's Crusade Against Them, 1892–1895*. Lanham, MD: Cooper Square Press, 2002.

Stuart, Mark A. *Gangster #2—Longy Zwillman, The Man Who Invented Organized Crime*. New York: Lyle Stuart, 1985.

Taggert, Ed. *Bootlegger: Max Hassel, the Millionaire Newsboy*. Lincoln, NE: iUniverse, 2003.

Wilson, Edmund. *The American Earthquake: a Documentary of the Twenties and Thirties*. New York: Doubleday & Company, 1958.

Wilson, Harold F. *The Jersey Shore*. Vol. 2. New York: Lewis Historical Publishing Company, 1953.

Wolff, Daniel. *Fourth of July Asbury Park: A History of the Promised Land*. New York: Bloomsbury USA, 2006.

ABOUT THE AUTHOR

Matthew Linderoth is a resident of the North Jersey Shore. He studies twentieth-century United States social history. He holds a bachelor's degree in history from Rutgers University and a master's degree in United States history from Monmouth University. He can be contacted at MatthewRLinderoth@gmail.com.